T0279524

NATURE'S OWN ATTRACTION

A HISTORY OF FLORIDA'S ROADSIDE SPRINGS

THOMAS KENNING

AMERICA
THROUGH TIME®
ADDING COLOR TO AMERICAN HISTORY

For Mom and Dad, whose idea of a vacation always included nature.

America Through Time is an imprint of Fonthill Media LLC
www.through-time.com
office@through-time.com

Published by Arcadia Publishing by arrangement with Fonthill Media LLC
For all general information, please contact Arcadia Publishing:
Telephone: 843-853-2070
Fax: 843-853-0044
E-mail: sales@arcadiapublishing.com
For customer service and orders:
Toll-Free 1-888-313-2665

www.arcadiapublishing.com

First published 2021

Copyright © Thomas Kenning 2021

ISBN 978-1-63499-314-2

Typeset in 10pt on 12pt Sabon
Printed and bound in England

CONTENTS

About the Author

THOMAS KENNING is an author, educator, and adventurer. He holds an MA in history from American University in Washington, DC, and teaches the subject in St. Petersburg, Florida. When he is not travelling to some far-flung corner of the Earth, he resides with his wife and daughter, planning his next improbable deed and trying to leave the planet a little bit nicer than he found it.

INTRODUCTION

The highways and byways of Florida—where the incomparable splendors of nature intersect with the overheated hucksterism and gaudy thrills of the roadside attraction! The prosperous decades just after World War II were a golden age for roadside attractions in the Sunshine State. The rise of the family automobile put Florida and its exotic flora and fauna (Gators! Palmettos! Manatees! Fresh-squeezed orange juice!) within reach for millions of curious Americans.

Entrepreneurs were happy to meet the demand, setting up for-profit nature parks around a number of Florida's most splendid natural springs and rivers. Glass-bottom boats and boardwalks abounded. The whole family could tour wildest Florida, and the kids wouldn't even get their shoes muddy.

How many road trippers caught their first glimpse of a manatee while waiting for the next mermaid show to start? How many families pulled over to break up the long drive with some lowbrow spectacle, and got back on the road talking about the audacious wonders of natural Florida?

For all their painted-on glitz and glam, these old school roadside nature parks, showcasing a sparkling spring and a menagerie of the peninsula's most colorful wildlife, served as the first and sometimes only experience of wild Florida for a given family. They were, for all their manifest silliness, an off-ramp by which many a young visitor embarked on a closer relationship with nature.

To distinguish themselves in this crowded field, many of these roadside operators upped the ante on weird. Who would pull over for plain old alligators when at Silver Springs you could also visit an island ruled by imported macaque monkeys? Who would care about the chance sighting of an armadillo when a part-time movie star and full-time hippopotamus named Lu roamed Homosassa Springs? Who needed manatees when real-life mermaids—scantily-clad and oh-so-lovely—performed a siren's song on the hour at Weeki Wachee?

Many of these gimmicky roadside nature parks ultimately failed as for-profit ventures, falling victim to an ever more efficient interstate system, to increased reliance on air travel—and to a man named Walt, who dispensed almost entirely with the nature angle

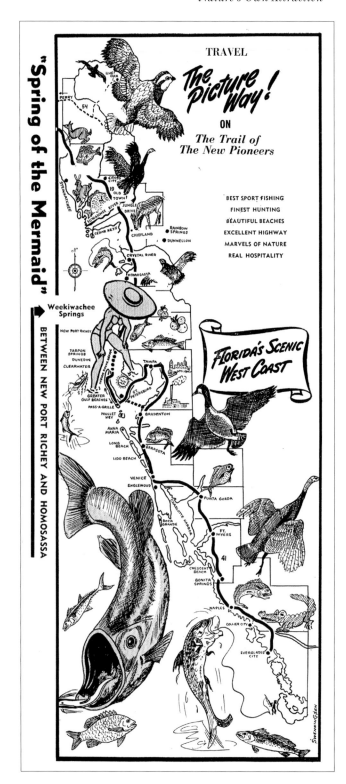

On the Trail of the New Pioneers—dating from 1949, this brochure for Weeki Wachee Springs included a map to ensure that any road trip to most-exotic Florida included a stop at the "Spring of the Mermaid." In a clever bit of marketing, it also doubled as a "wish you were here" postcard, with space for postage and a personalized message on the reverse side. [*Courtesy of State Archives of Florida*]

that marked this earlier generation of parks as something uniquely Floridian. Disney World, with its Hollywood production values and unprecedented brand awareness, would instead go "all in" on the fantasy element that Florida men like Newt Perry had pioneered to such great effect.

The glorious modern age of Florida tourism was in sight.

But some of these roadside attractions have survived, nearly as wild and wacky as ever, fully integrated into the state park system. From Silver Springs State Park and Homosassa Springs Wildlife State Park to Rainbow Springs State Park and Weeki Wachee Springs, they continue to operate today as publicly-subsidized relics of a truly woolly and weird chapter in Florida's history.

Come along for the ride—equal parts road trip and nature hike—into this vital, strange period in Florida's cultural heritage. But please, for your own safety: don't feed the monkeys!

Not a species native to Florida. Migratory, but well-established. Rainbow Springs, 2020.

TIMELINE

CIRCA 530 MILLION YEARS AGO: The land we now call Florida forms along the northwest coast of Africa. Florida will remain submerged for most of the next 500 million years. The limestone strata undergirding the state is a product of this period—many millennia worth of marine shells, compacted and fossilized.

CIRCA 200 MILLION YEARS AGO: When Pangea breaks up, a submerged Florida sticks to the North American continent. The state's upper sandy strata is, in part, silica eroded over the same period from the once snow-capped Appalachian Mountains.

CIRCA 2.5 MILLION YEARS AGO: Ice collects at the poles. Sea levels begin to drop as the Earth's climate enters a cool period. Portions of a shallow sea to the south of the North American continent are exposed to open air.

CIRCA 100,000 BCE: As sea levels continue to fall, Florida's artesian springs begin to flow with fresh water.

CIRCA 9000 BCE: The first humans inhabit Florida's interior, regularly fishing and hunting in the vicinity of its artesian springs. Prehistoric fossils and bones—from giant sloths, manatees, saber-toothed tigers, camels, and buffalo—found in and around the springs date from this period.

1528: Spanish conquistador Pánfilo de Narváez lands somewhere near modern St. Petersburg. Fronting a force of 300 armored men, he leads a disastrous expedition through the kingdom of the Timucua, engaging in a short but bloody battle in the region known as Ocali.

1848: On July 1, settler James Rogers obtains a grant for eighty acres of land including Silver Springs, paying the U.S. government $1.25 an acre. Any remaining Native American inhabitants are evicted from the region in what are dubbed the Seminole Wars—a nearly fifty-year period of conflict in which native peoples are driven from the land through the coordinated action of the U.S. Army and armed settlers.

1850: The small settlement of Ocala is home to fifteen families. Silver Springs and the river it feeds develop as a transportation center for Central Florida's settlers. Enslaved men use poles to guide barges—laden with lumber, produce, and other trade goods—through the gentle currents of the Silver, Rainbow, Homosassa, and Weeki Wachee Rivers.

CIRCA 1860s: After the Civil War, steamboats plying the Silver River begin carrying the first tourists to the headsprings.

1887: The "Mullet Train" begins service between Ocala and Gulf Coast, stopping regularly for resupply and lunch at Homosassa Springs.

1889: Rock phosphate is discovered in the vicinity of Blue Springs (known today as Rainbow Springs). This boom industry upends the area around the springs, leaving behind a landscape of cratered pits and tailing piles.

1916: *The Seven Swans* is filmed at Silver Springs, the first of numerous motion pictures produced in Florida's clear spring waters.

1924: Businessman Bruce Hoover rides the Mullet Train and is so smitten by Homosassa Springs that he will spend the better part of the next decade attempting to develop the area.

1924: Carl Ray and W. M. "Shorty" Davidson purchase Silver Springs, presiding over the attraction's golden era.

1926: The messy remnants of mining operations at Blue Springs are rehabilitated—planted over with botanic gardens and given new life with a series of artificial waterfalls. The whole area is rechristened "Rainbow Springs."

1941: The Mullet Train ceases operations.

1945: David Newell opens an attraction at Homosassa Springs along the brand-new US 19.

1947: Also along US 19, Newt Perry opens Weeki Wachee Springs, which is alternatively said to mean "Little Spring" or "Winding River" in the Seminole language.

1949: Paradise Park opens at Silver Springs, the only major roadside attraction serving African Americans during the height of racial segregation in Florida.

1955: US 19 is extended as far south as the newly-opened Sunshine Skyway Bridge spanning Tampa Bay. Beyond this, it connects to US 41—making for a convenient through-trip along the West Coast, through the Everglades, and all the way to Miami.

1957: Howard T. Odum, a professor at University of Florida, publishes his seminal study of Silver Springs, quantifying the energy of the entire system—accounting for the sun's rays as they reach the plant life, the movement of the water, even the bread tossed by tourists to the ducks. He is among the first scientists to describe an ecosystem, a complex and interdependent series of relationships that constitute a dynamic whole.

1959: Newt Perry cashes out, selling Weeki Wachee to the American Broadcasting Company (ABC).

1962: ABC acquires Silver Springs from Carl Ray and Shorty Davidson for a reported $7.5 million, bringing their near forty-year reign to end with a handsome payday.

1963: The first segments of I-75 in Florida are completed, running from the Georgia border to Lake City by the end of the year. The freeway will extend to Tampa by 1969, diverting most long distance through-traffic away from US 19 and US 41.

1964: An updated underwater observatory opens at Homosassa Springs.

1964: Lucifer the hippopotamus, better known simply as Lu, arrives at Homosassa Springs.

1966: The city of Weeki Wachee is officially incorporated. While the municipality never has a population exceeding double digits, this act serves to put Weeki Wachee on the map in a literal sense.

1969: Paradise Park closes in the wake of federally mandated integration across the state of Florida.

1971: Disney World opens to the public.

1973: SeaWorld opens in Orlando.

1973: In the midst of a deepening oil embargo imposed by OPEC nations, President Nixon issues an executive order lowering all Interstate highway speed limits to 55 MPH.

1974: Rainbow Springs closes as a roadside attraction.

1975: McCoy Air Force Base is deactivated and turned over to the city of Orlando, expanding civilian aviation in the burgeoning resort town.

1978: ABC opens Wild Waters, a water park operated in conjunction with Silver Springs.

1982: Buccaneer Bay opens at Weeki Wachee.

1984: The old Rainbow Springs property is acquired by a firm known as Chase Ventures, which plans to redevelop the site.

1984: A vocal group of citizens successfully lobbies Citrus County to purchase Homosassa Springs.

1984: ABC sells both Weeki Wachee and Silver Springs to a firm known as Florida Leisure Attractions.

1986: The entire Rainbow River is designated by the state as an aquatic preserve.

1988: The State of Florida assumes ownership of Homosassa Springs, forming a state park around it.

1990: The State of Florida acquires Rainbow Springs. A group of dedicated volunteers begins clearing fifteen years' worth of overgrown brush, paying special attention to the removal of invasive species.

1992: Rainbow Springs opens to the public with volunteer-led weekend-only hours.

1993: The State of Florida acquires the headsprings at Silver Springs. Daily operations continue in the hands of private contractors.

1995: The State of Florida assumes full-time operations at Rainbow Springs State Park.

1999: The Weeki Wachee attraction is sold to the city of Weeki Wachee.

2008: The State of Florida assumes ownership of Weeki Wachee.

2012: A study finds that the flow at Silver Springs has decreased from 790 cubic feet per second in the 1990s to 535 cubic feet. The aquifer has been diminished by a dramatic increase in human development—accompanied by an overuse of groundwater—in the area around the springs. In the same period, nitrate runoff from fertilizer has caused an uptick in algae blooms, clouding the once crystal-clear water.

2013: Silver Springs State Park is created when the last private vendor ceases operations.

2020: In January, Lu celebrates his sixtieth birthday.

2020: In June, the state of Florida formally dissolves the city of Weeki Wachee, population thirteen.

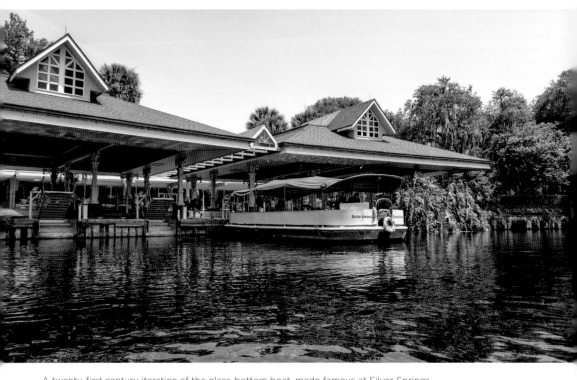

A twenty-first century iteration of the glass-bottom boat, made famous at Silver Springs.

1

SILVER SPRINGS STATE PARK

What the Pyramids are to Egypt, so are the ROMANTIC, MYSTERIOUS, MIRROR WATERS of the Ocklawaha River and Silver Springs to Florida.

Promotional materials for a steamboat tour of Florida, nineteenth century.

Silver Springs has been an active tourist attraction since the 1860s, making it the silver-bearded patriarch of them all—the oldest commercially-operated attraction in Florida, a state spoken of in hushed voices throughout the known world for its many fabled tourist destinations.

Under one banner or another, Silver Springs has dabbled in almost every trend in themed roadside attractions—from glass-bottom boats to water parks and so-called jungle cruises. The park has also traded in some of the most ethically fraught aspects of the entertainment industry, from the offhand importation of invasive species to the energetic enactment of Florida's staunch segregationist laws.

In the modern day, Silver Springs and its mixed legacy have been adopted into the Florida State Park system. Under this agency's eye, for the first time in more than a century and a half, an attraction that predates the roadside itself is reverting to something approaching its native condition.

ANCIENT ORIGINS

In the beginning, God gathered the waters together into one place, separate from the sky, separate from the earth—except in Florida, where the line between "water" and "earth" has always been blurry.

The history of Silver Springs is shaped by this geology.

During the Jurassic Period, the Earth was much warmer. There were almost certainly no ice caps or substantial glaciers anywhere on the planet, so sea levels were much higher. For this reason, you will find no dinosaur skeletons in the state of Florida—

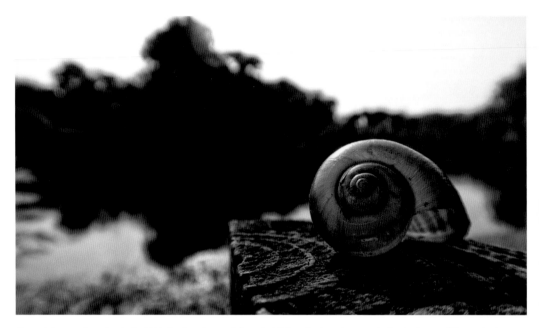

The calcium carbonate shell of this freshwater snail found at Silver Springs is very similar to those of its ancient saltwater cousins, whose biomass settled out over hundreds of millions of years to form Florida's limestone substrate.

hundreds of millions of years ago, the entire low-lying peninsula sat at the bottom of a shallow sea.

The creatures who made their ancient home in this "Florida Sea," such as oysters, mussels, clams, and coral, ancestors of the many invertebrates still thriving in the balmy, biodiverse waters off Florida today, used calcium carbonate ($CaCO_3$) found in seawater to generate their shells. Over the millennia, as countless generations of these organisms completed their natural life cycle, their calcium-rich shells settled out on the shallow seafloor. These remains were crushed and dissolved by wave action and other natural processes, gradually forming the compacted limestone sediment that undergirds much of Florida today.

This porous layer of limestone serves to collect, store, and purify rainwater as it seeps down as much as 2,000 feet below the Earth's surface.

The Floridan aquifer—the reservoir from which all our drinking water is drawn—is fed entirely by the rain that falls from the sky. As this rainwater filters through the limestone beneath our feet, it sometimes dissolves sediment, forming the infamous sinkholes that are the phantom nightmare of any Florida homeowner.

Subterranean water can flow in the opposite direction, too. The natural pressure of the aquifer pushes clarified water back to the surface, forming the numerous artesian springs that helped to sustain Florida's first pioneers.

You see, humans have occupied the land around these valuable sources of clean, cool drinking water for thousands of years, probably since the first prehistoric nomads ventured upriver from the coast around 10,000 years ago. During the last ice age, humans were fishing at Silver Springs and likely hunting mammoths, giant sloths, and other megafauna lured there on the promise of a refreshing drink.

Rainbow Springs has been flowing for thousands of years, issuing forth cool, filtered water since prehistoric times—when mastodon still roamed the emerging Florida peninsula.

Prior to the arrival of the retiree, the American alligator was Florida's most iconic inhabitant. They continue to live and thrive in Florida's springs today, as they have for thousands of years.

Kayakers on the Rainbow River reenact an ancient rite—humans have inhabited the areas around the springs for 10,000 years. Ancient inhabitants were plugged into trade networks in which goods were relayed from at least as far away as the Great Lakes. The final leg of such a transit which would have run along Florida's spring-fed rivers.

More recently, these springs were the pumping, flowing heart of the first generation of Florida's roadside attractions—and by extension, the basis for all the history discussed in these pages.

ROADSIDE HEYDAY

In the years immediately following the Civil War, steamboats laden with tourists plied the waters of the Silver River. A generation earlier, similar vessels had carried little more than citrus, tobacco, and timber harvested along the river's banks. However, the emerging trade in tourism offered the potential for far greater profits. Visitors, mostly from Northern states, wished to travel in high style and comfort—and were willing to pay accordingly for privilege. Business was so vigorous that it supported not one, but two competing companies on the Silver River alone—the Hart Line and Lucas Line.

The primary attraction—apart from the general ambience of cypress, Spanish moss, and alligators—was the river's headwaters. These were the so-called Silver Springs, where the river seemed to burst forth from the Earth itself, fully formed, as pure as any one of the four rivers of Eden.

By the early 1880s, a newly extended railroad spur helped to set new records for attendance at Silver Springs. Sometime later, two local men—Hullam Jones and Philip Morrell—began to tinker independently with their own versions of a novelty that

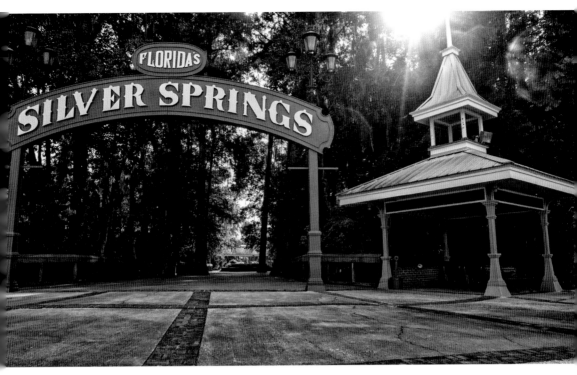

With its serif typeface and earth tone field—flanked by gazebos that look like something straight out of the late nineteenth century—the latest in a long line of entrance signs at Silver Springs hearkens back to the spring's origins as a tourist attraction in the years immediately following the Civil War.

Riding the Silver River was only half the fun for those first travelers, who were effectively pioneering American tourism as we know it. Accounts exist of rough-and-tumble passengers, who paid an $18 round-trip fare, often firing guns at wildlife along the banks of the river.

"That's one of my disappointments, the fish leaving and a lot more algae growing," Roosevelt Faison, a glass-bottom boat pilot with fifty-seven years of experience told *The Gainesville Sun* in 2013. "Years ago, you could stand on the dock and look out on the river and the eel grass would glow, that's how shiny it was. Now, it's covered with algae."

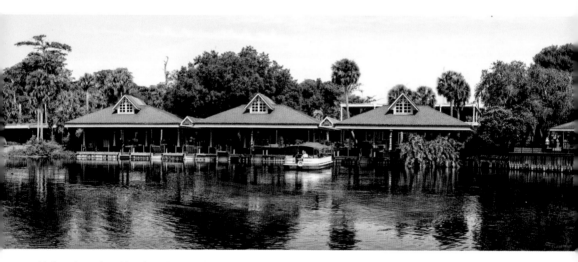

Hullam Jones is said to have invented his glass-bottom rowboat so that he could better identify and recover submerged cypress logs. Whether or not Jones was the original innovator, it was probably Philip Morrell who first applied glass-bottom technology to the tourist trade. Either way, a recognizable version of these docks has existed at Silver Springs since the 1920s.

would shape the future of tourism in Florida for several generations. Their handmade prototypes may have looked rough, but the result can't be denied—both men could credibly claim a hand in inventing the glass-bottom boat. It's not clear when this invention was first applied to tourists, but the earliest firm accounts of a regular glass-bottom boat attraction at Silver Springs date the opening years of the 1900s.

As kitschy and quaint as it might seem today—in our era of snorkels, Scuba, and made-for-television *Planet Earth* documentaries, all offering revelatory 4K glimpses into underwater worlds—it's important not to underestimate just how remarkable the glass-bottom boat must have seemed to any denizen of the late nineteenth century. Here was a literal window into a fantastic, marvellous side of nature otherwise inaccessible to the average person. The transparent waters of Silver Springs, teeming with aquatic life, were the perfect venue in which to prove the concept.

Is the glass-bottom boat a gimmick? Sure! But it's one that fosters in everyday people a greater sense of wonder about the natural world. And, to boot, the glass-bottom boat does this in an almost entirely non-invasive way. No animals are hurt, transplanted, or restrained against their will—and travelers return home to tell awestruck tales of nature's glory. Of all the over-the-top gimmicks devised to keep the attraction relevant over the decades, the glass-bottom boat—whether in its original form as a rowboat, or in one of its later gasoline and then electric-powered iterations—is the single most enduring emblem of Silver Springs.

A stream of entrepreneurs and concessionaires as steady as the spring itself would come and go over the next 125 years, but a few would stand above the rest.

Carl Ray and W. M. "Shorty" Davidson turned up on the scene in 1924. Both men were trying to purchase the springs—and decided to pool their resources rather than allow themselves to be drawn into a bidding war. During their nearly forty-year reign, Ray and Davidson would invest heavily in Silver Springs, most notably constructing the iconic Tourist Center, the historic shops and boat dock that welcome visitors to Silver Springs even today.

Hollywood also came calling, enticed like so many others by the pristine waters and subtropical vegetation which lines the banks of the river. Films such as two sequels to *The Creature from the Black Lagoon*, *Thunderball* (1965), and several *Tarzan* movies were shot on location at Silver Springs, cementing the park's enduring legacy in popular culture.

Silver Springs also attracted numerous displays focused on Florida's wildlife—most notably those of Ross Allen, an Ocala native who spent countless hours as a boy catching snakes and turtles along the Silver River. In 1930, he approached Ray and Davidson with a proposal to host a reptile show at Silver Springs. The show proved so popular that, while the man himself has long since passed, the Florida State Park system has named an island after Allen in the modern day. Allen managed to build a career on a unique combination of memorable entertainment, public education, and honest-to-goodness scientific work. Notably, Allen put his large collection of poisonous snakes to work for the U.S. Army during World War II, producing a steady supply of antivenin for the benefit of soldiers in the field.

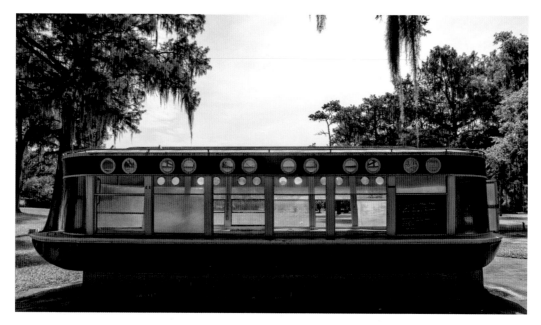

This concession stand is modelled on the style of glass-bottom boat in use during the attraction's mid-twentieth-century heyday.

The stand is often unused these days, like so many other faded elements of the attraction. Throughout most of the twentieth century, the west side of the springs (now a picnic area) was a sandy beach. To the east, Tommy Bartlett's Deer Ranch—a petting zoo—operated between 1954 and the mid-70s, not far from the Prince of Peace Memorial, which featured elaborate wood-carvings depicting the life and times of Jesus Christ.

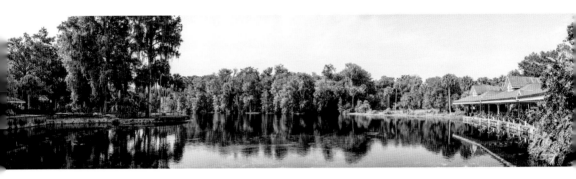

"To see the springs in their most perfect beauty one must ... get into a rowboat, take along a guide to do the rowing, and linger over the places where the best views can be had into the mysterious depths." -*A Southern Jaunt* (1886). This promotional brochure for a then-new eighty-room hotel at Silver Springs makes no mention of glass-bottom boats.

A June 17, 1955, fire gutted the shops and offices at Silver Springs, which Ray and Davidson had constructed in a charming Spanish-revival fashion. They were replaced by the current pavilion, designed by Florida native Victor Lundy in the Sarasota-modern style.

For years, an African American storyteller named Aunt Silla performed her act near this spot. Allegedly 110 years of age when she passed in the 1950s, Silla claimed to be a firsthand participant in the legend of the Bridal Chamber, a riff on the tragedy of Romeo and Juliet that found both protagonists swallowed by the eponymous cavern, which still bubbles away at the bottom of the springs.

These statues, leftover from an episode of the TV series *I Spy* shot at Silver Springs in the mid-1960s, are a popular feature of the glass-bottom boat tour. A dive team employed by the park occasionally pressure washes them to mitigate algae growth.

The action-adventure TV series *Sea Hunt* (1958-1961)—produced by the eccentric Ivan Tors—filmed a number of sequences at Silver Springs, including on this now crumbling dock. Tors allegedly conceived his most famous creation *Flipper* while working here and would later bring a menagerie of animal performers to Homosassa Springs.

A water moccasin—or is it a harmless water snake?—suns itself along the Silver River. As a teen, Ross Allen came here with friend Newt Perry to capture such snakes for fun. With the support of Ray and Davidson, a twenty-one-year-old Allen turned his passion into a career, opening his Reptile Institute at Silver Springs in November 1929.

Until his retirement in 1975, Allen produced thrilling reptile shows on the half hour while also conducting sober research out of a now-demolished building near the beach on the east side of the headsprings. This theater hosts nature presentations on a swampy island named in Allen's honor—a nod to his legacy as an ambassador of wild Florida.

A gifted showman, Allen became a media darling, appearing in dozens of newsreels and TV specials. In one clip from the early 60s—"A Guided Tour of Ross Allen's Reptile Institute"—he cuts a larger-than-life figure, posing shirtless on the bow of his boat before wrestling gators and anacondas in the crystal clear waters of Silver Springs.

A statue of Osceola commemorates Seminole resistance to U.S. Indian removal campaigns of the 1830s and 40s. In 1934, a group of Seminoles were invited to build and inhabit a Seminole village for the edification of Silver Springs tourists. The end result was a precarious combination of embassy and fishbowl, and a spiritual forerunner of Epcot's world showcase.

Speaking to the *Ocala Star Banner* as the Seminole constructed their new village—not far from this modern-day fountain—a representative of Silver Springs said, "They hope someday they will have revenge. They don't want to talk to the white man." Though sensationalized "savage warrior" stereotypes might sell tickets, the *Star* reporter found Seminole leader Sam Tommy gregarious and "optimistic."

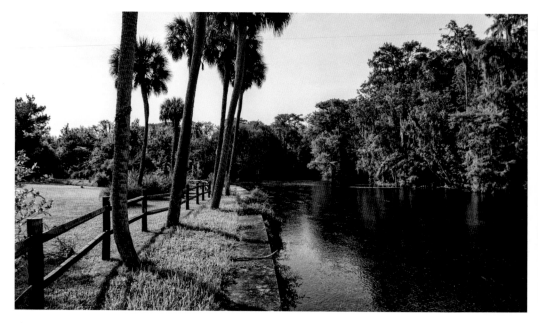

The Seminole settlement persisted until the 1970s, when it closed along with so many other fixtures of Silver Springs' heyday. Despite sometimes questionable patter from the park's publicity men, the village was, during its forty years of operation, among the highest profile examples of Native American self-representation east of the Mississippi.

Less charming—and downright shocking to modern eyes—was the decision of one Colonel Tooey (that's a given name, not a title, but it suited his take-charge personality just fine) to create an island at Devil's Elbow, about a mile downstream from the headsprings. In 1938, he imported six Asian rhesus macaques to populate that artificial island—apparently without realizing that this species were swimmers as accomplished as Newt Perry and his multitude of miraculous mermaids.

There was no Google in those days to check a fact so basic, but still—from this reckless miscalculation, Tooey's monkeys promptly escaped the island, founding the only free-range, self-sustaining troop of macaques in North America. They have outlasted Tooey's Jungle Cruise ride by many decades. They have no predators. They breed readily. And long story short, more than 300 of their descendants roam the forests of Silver Springs State Park to this day.

Florida's staunch commitment to racial segregation meant that for decades, the roadside attractions discussed in this book were accessible exclusively to white patrons. This fact is particularly vexing considering how many of the attractions' employees, including the glass-bottom boat pilots, were African American. In a scene not so far removed from the bygone days when enslaved men moved barges up and down the Silver River, blacks were "good enough" to serve the white clientele, usually for exceedingly modest wages—but no amount of money could buy room for their towels on the beach.

A mother macaque and her baby demonstrate their facility as swimmers in the waters of the Silver River. They are feral descendants of Colonel Tooey's original troupe, supplemented by an additional six monkeys in 1948—even after Tooey knew they could swim. Their self-sustaining extended family numbers around 400 and ranges as far as Ocala National Forest.

The macaques are playful and charismatic, performing belly flops into the river from the treetops for their own apparent amusement.

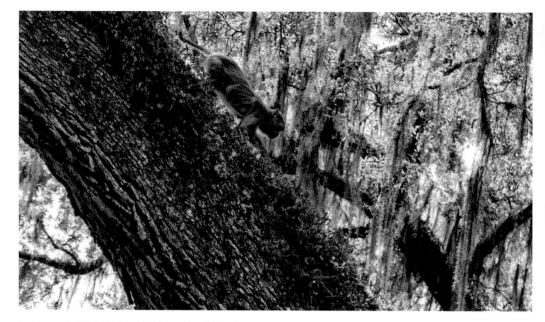

Beginning in 1984, the Florida Fish and Wildlife Conservation Commission mounted a sustained campaign to contain the ballooning macaque population. At least 200 free-range monkeys were trapped and sold for laboratory testing. Animal rights advocates decried this as cruel, arguing that sterilization would be a more humane, if less profitable remedy for Florida's most charismatic invasive species. The effort faltered under public scrutiny.

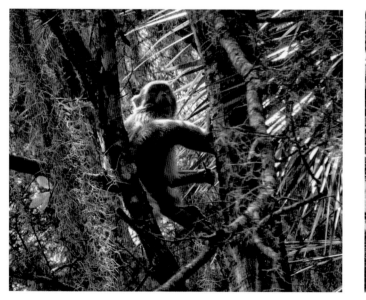
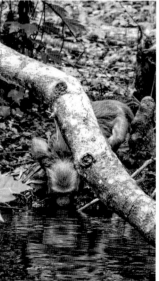

Steve Johnson and Jane Anderson of the University of Florida estimate that approximately 25% of the Silver Springs' macaque population carry herpes B, which can be transmitted via a bite or a scratch, and can be fatal to humans. It is illegal to feed the monkeys, and visitors to the park are advised to keep their distance.

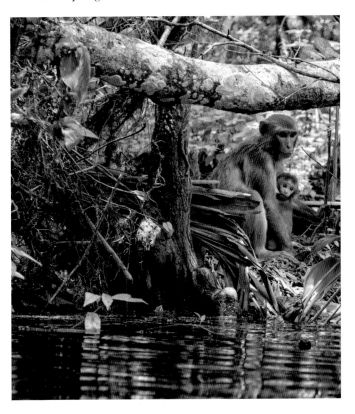

Recognizing the sizable potential of this untapped market, Ray and Davidson opened Paradise Park in 1949. Here, they replicated most aspects of their whites-only operation upriver—a chance to "See Florida's Silver Springs from Paradise Park for colored people," as the promotional materials proclaimed with a bluntness typical of a period in which racism wasn't whispered or implied, so much as it led the sales pitch.

As at Silver Springs proper, general admission to Paradise Park was free, but specific attractions were accessible for a fee—from swimming to glass-bottom boat rides and even a segregated "Ross Allen's Wild Animal Exhibit." At its peak, this blacks-only attraction was a resounding commercial success, welcoming as many as 100,000 visitors a year. Ultimately, Paradise Park closed quietly in 1969, not long after the State of Florida lost its protracted legal fight against the integration of public spaces.

In 2015, Lu Vickers and Cynthia Wilson-Graham published *Remembering Paradise Park: Tourism and Segregation at Silver Springs*, an authoritative oral history documenting the attraction's complicated history. Born of racial animus, Paradise Park paradoxically offered a rare sanctuary from the same. Ocala native and prominent civil rights activist Dr. Dorsey Miller told the authors:

> We used to ride our bikes to Paradise Park. [...] And when it closed, I felt a loss. I never had a desire to go on the other side, Silver Springs. It was different, you see. At Paradise Park, under the pavilion, we had what we used to call a "piccolo." We used

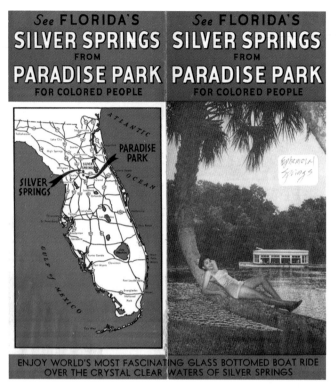

A 1949 brochure advertising the segregated Paradise Park at Silver Springs. Though the map implies some degree of geographic distance between the two attractions, in reality all separation was socially imposed—the two operations practically abutted each other, detached only by a bend or two in the river. The brochure goes on to list amenities available to visitors and retells the legend of the bridal chamber. [*Courtesy of State Archives of Florida*]

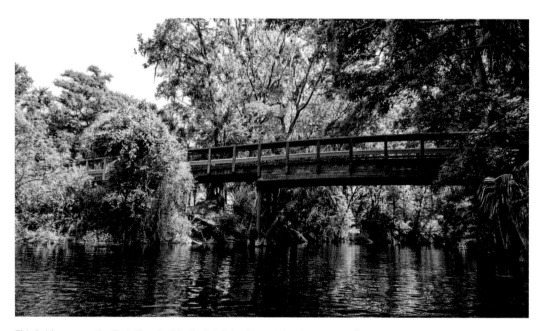

This bridge spans the Fort King Paddle Trail. It links the mainland to Cypress/Ross Allen Island, which housed Ross Allen's reptile shows and a few other attractions from the 1970s on. Like much of the park, the island has largely been reclaimed by nature.

to play records, dance and have a good time. [...] We could go to Paradise Park and socialize and interact without making any excuses and without feeling as if we were guests. Paradise Park was home for us, just as Silver Springs was home for whites. After integration, we were not made to feel welcome. All of our traditions were lost. After I had children, I went over to Silver Springs to ride the glass-bottom boat, and it was just altogether different. It was like being a guest in my own home. I never went back again.

As Dr. Miller's story illustrates, the ongoing project of building a healthy interracial community has been a painful and disruptive one. The end of legal segregation didn't immediately heal centuries-old injuries. As with a real, bodily injury, recovery is going to take some hard work and rehab.

Aside from the memories, the only evidence of Paradise Park today is a historical marker at the park's former entrance, placed in 2014. It is the first Florida Heritage Marker dedicated to the African-American experience anywhere in Marion County. Vickers and Wilson-Graham continue to advocate for the revival of Paradise Park within the public park system, taking its rightful place alongside Silver Springs, Weeki Wachee, and the other parks covered in this volume. Such an addition would constitute a reclamation of sorts—an affirmation that even the most fraught elements of our past are worthy of commemoration and dialogue.

Until such time, the public memory of roadside Florida will remain fractured and incomplete, divided along the same racial lines of omission that led to the creation of Paradise Park back in 1949.

Ray and Davidson held court at Silver Springs until the early 1960s, when they sold the park to the American Broadcasting Company. At the time, ABC was eager to diversify its holdings along the model of sometime-corporate partner Walt Disney's latest triumph in Anaheim, California. Despite the acquisition of a portfolio of established Florida attractions—and a substantial investment in their subsequent improvement and modernization—ABC's flirtation with the theme park industry would ultimately wither on the vine.

You may already have heard—but a few years later, Walt decided to conquer the Sunshine State, too.

By the early 1970s, some of that old Silver Springs luster had begun to fade. Just an hour or so to the south, Disney World and SeaWorld were redefining American expectations of what a theme park could be, presenting entertainment on a scale and with production values against which a more modest attraction like Silver Springs could not reasonably compete.

What self-respecting kid wanted a glass-bottom boat ride past some palms swaying gently in the breeze when there was a simulated submarine battle against a simulated sea monster a mere 20,000 simulated leagues away?

ABC's would-be empire of established roadside properties almost immediately came to look like a pretty feeble pretender to the theme park crown.

At the very least, Silver Springs was no longer a destination unto itself—simultaneous with the rise of Orlando's parks, jet airplanes began to displace automobiles as the preferred mode of transport for Northerners descending on Florida. At least when automobiles had replaced railroads and steamboats a generation or two earlier, Highway 27—and more recently, Interstate 75—had run within convenient proximity of the front gates at Silver Springs, granting the attraction a fighting chance in the evolving

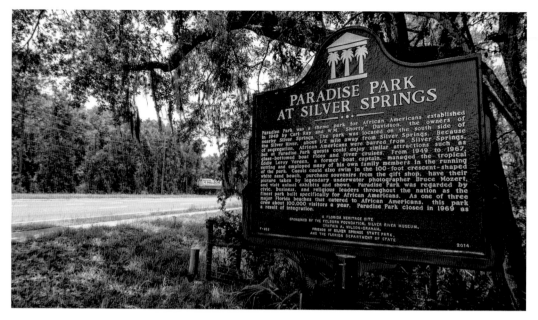

Paradise Park has garnered more attention in recent years. While its abandoned grounds are included in the state park, they are officially inaccessible.

Opened in 2004, the Fort King River Cruise was a history-themed attraction featuring a model "cracker" homestead and a scale replica of Fort King, an American redoubt dating to the Seminole Wars. The cruise was shut down in 2013 when Silver Springs became a state park, but the rotting vestiges can be seen in various states of collapse along the lush Fort King Paddling Trail.

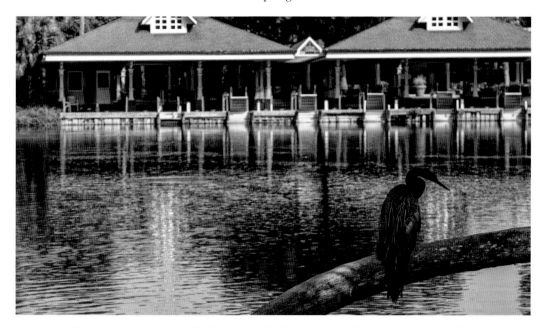

An anhinga perches on the so-called "lucky palm," which bends in a horseshoe shape over the retaining wall toward the Silver River. The tree featured prominently in advertising of the 1950s and 60s, usually with model Jackie Bingham, wearing a come-hither yellow two-piece, posed beside it. Patter from the boat pilots suggests that having your photo taken with the lucky palm will result in five years' good fortune.

marketplace. Not so with airplanes, which by their very nature, bypass all diversions between points A and Z.

These convergent factors marked the beginning of a precipitous downward spiral in attendance, culminating in the gradual assumption of Silver Springs into the state park system. No water parks—no new gimmicks devised by ABC or any of the other operators that followed in quick succession—could pull the park out of its slow motion commercial decline.

IN THE STATE PARK SYSTEM

In 1985, the State purchased the land surrounding the historic attractions, dubbing the newly public lands Silver River State Park. This action probably helped to spare Silver Springs from the development boom gripping the state in the last quarter of the twentieth century. In 1993, the state acquired the land under the privately operated attractions, becoming a *de facto* landlord as the roadside version of Silver Springs limped on into the 2000s. Finally, in 2013, Florida assumed control of the whole shebang, formally consolidating the entire area into Silver Springs State Park.

The state closed down most of the roadside elements of Silver Springs, including the remnants of a multimillion-dollar 1997-1999 makeover with such self-explanatory

names as World of Bears, Big Gator Lagoon, and Panther Prowl. A decade after this takeover, little more than the glass-bottom boats and the macaques remain.

The state's larger mission, appropriately, is the implementation of a broad conservation plan restoring the park to something approaching its native condition, plus or minus a monkey or two. The park has witnessed a resurgence of wildlife in recent years, including such Sunshine State stalwarts as nine-banded armadillos, white-tailed deer, foxes, and American alligators, as well as the occasional coyote, bobcat, and, even more seldom, the Florida black bear.

Under public management, the springs themselves have regained some of their famed clarity, lost in previous decades to nitrate runoff from nearby commercial and residential development. This is an ongoing give-and-take with surrounding landowners, however, cattle defecate prodigiously, HOAs demand well-watered fertilizer-green lawns, and ingrained norms die hard. Continued restoration of the springs will require collective action as the Floridians eke out a new, more sustainable version of business as usual.

Silver Springs is a collective name applied to thirty different vents strung out like beads along the first .6 miles of the Silver River, which itself flows through dense cypress forest for another five miles before joining the Ocklawaha River.

About 45% of the Silver River's volume comes from Mammoth Spring (aka the Main Spring), which has two vents in the pool below the boat docks. Its average flow has decreased in recent decades, down from 510 million gallons per day in 2000—a change attributed to depletion of the aquifer by unsustainable water use in activities ranging from cattle ranching to new housing developments.

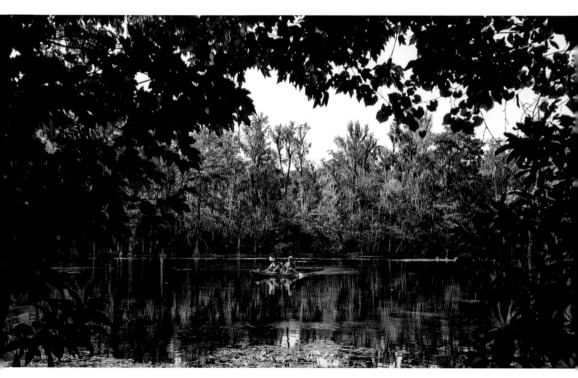

Since 2013, the state has taken numerous measures to improve water quality at the springs. These include mitigation of surface runoff and reduction of water use within the park, achieved through the replacement of nonnative plant species with drought-resistant native varieties and by the closure of water-intensive exotic animal exhibits opened during the 1997-1999 renovation.

Florida's aquifer is recharged only by rainfall. Every drop of water from your tap is drawn from this vast—but finite—underground reservoir. Since consumption of water for human activities now regularly outpaces the volume of rainfall, it's only a matter of time before the peninsula dries up—like this flower at the end of the season.

The Florida Springs Institute estimates that flow from Florida's springs, a direct indicator of aquifer health, has declined 32% between 1950 and 2010. This is directly observable at Silver Springs, where low flow combined with increased nitrate runoff has produced largescale algae blooms. A 2013 census found that the fish population at Silver Springs has plummeted 90% from baseline surveys in the 1950s.

In a sense, this isn't simply the spot where a remarkably beautiful river arises—as if by magic—from the Earth. Rather, Silver Springs is where modern Florida itself springs from the Earth—the Florida of theme parks, larger-than-life entertainment, and promises delivered not quite as advertised.

You and I know there is so much more to Florida than just those qualities. But *that* Florida—the one with a tourism tax, but no income tax—is very much the state we call home.

For that, perhaps we owe Philip Morrell, Carl Ray, Shorty Davidson, Ross Allen, and Colonel Tooey a respectful salute. They were men who could see a good thing right in front of them, as if through crystal-clear waters. And, more to the point, they were men who knew how to make a few bucks off that good thing.

Oh, but really—watch out for the macaques! They may be cute, but they carry an infectious strain of herpes.

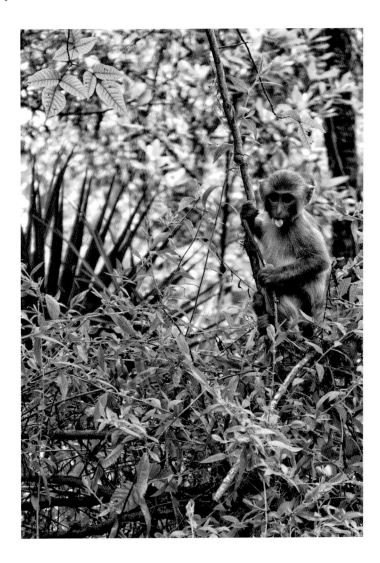

Rainbow Springs produces between 400 and 600 million gallons of fresh water per day, giving rise to the Rainbow River, which meanders for 5.7 miles before merging with the Withlacoochee River at Dunnellon.

2

RAINBOW SPRINGS STATE PARK

It will restore your faith in Fairy Tales. Rainbow Springs is Robin Hood, Jules Vern, and Huckleberry Finn all wrapped up in one place.
Rainbow Springs is modern, clean, new.
Rainbow Springs is an honest count at the cashier's window.
<div align="right">Vintage Rainbow Springs promotional material</div>

The land around Rainbow Springs hides its trauma well.

In the 1930s, this old phosphate mine—the scene of processes as disruptive to the land as any devised by man—was transformed into a roadside attraction that pretty convincingly portrayed the scars of industry as a kind of mystical landscaping, verdant, green, and lush.

By 1975, a few manmade waterfalls and a pristine swimming hole—no matter how miraculous their existence in the historical sweep of things—were sorry competition for an entire Magic Kingdom ninety minutes to the southeast.

But where private capital failed to build a sustainable business, the initiative of the surrounding community would culminate in yet another remarkable rebirth for Rainbow Springs as a botanical garden and nature preserve in the Florida State Park system.

ROADSIDE HEYDAY

Once the rolling hills of North Florida drop away, the road and the landscape beyond are almost shockingly flat. Except where man has had his way, the pastureland and citrus groves tilt ever so gradually, almost imperceptibly into the swamps, and the tallest thing for miles are the live oaks.

But here, near Rainbow Springs, man has had his way.

In the middle of the nineteenth century, British scientists learned that they could derive a potent fertilizer from phosphate, readily available in a 20-million-year-old layer

A southeastern five-lined skink flits just out of reach near the headsprings. They can grow to be eight inches in length and are one of Florida's most widely occurring skinks.

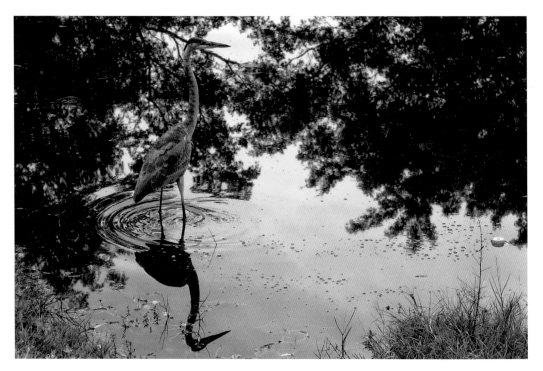

A great blue heron hunts along the Rainbow River. This bird carefully stalks its prey, standing still as a statue—before striking in a flash when some unfortunate fish ventures within reach.

of fossilized biomass lying mostly far below the Earth's surface. Believe it or not, mining down through all this rock was easier than accessing humanity's previous industrial scale source of fertilizer—sun-dried bird *guano* harvested in near slave-labor conditions on desert islands the world over.

In 1889, Albertus Vogt discovered the first viable sources of hard rock phosphate in Florida, primarily in the Dunnellon area, where it lay within relatively easy reach near the surface. This spurred a speculative bubble as Vogt and others bought up as much land as they could, hoping to strike the motherlode.

An 1891 guide—*The Phosphates of America: Where and how They Occur; how They are Mined; and what They Cost*—published at the height of the boom, noted that "many a cracker homesteader who went to bed a poor man woke up in the morning to find himself a capitalist." Reportedly, land that was previously worth a few dollars was now selling for hundreds.

The boom fuelled the growth of an unassuming town—Juliette, founded in 1883 right near what turned out to be a visually-arresting, phosphate rich site known as Blue Springs. Pits around Blue Springs yielded cartloads of phosphate and carried such colorful, optimistic names as "The Tiger Rag" and "Early Bird." But the salad days wouldn't last.

More abundant, more easily accessible deposits would push Florida's phosphate industry toward the central portion of the state. As a result, almost as soon as it hit, the wave crested—and phosphate mining in the Dunnellon area was no longer profitable. The winsome village of Juliette wilted as the mighty boom turned into a colossal bust. Its post office closed in 1926, and the site of the town lies abandoned and forlorn in today's Rainbow Springs State Park.

In their wake, shuttered phosphate mines left deep pits and towering piles of tailings—enduring footprints of the steam-powered machinery which so briefly stalked these forests, gone now, as surely as the extinct creatures whose ancient remains they had harvested with such grim efficiency.

Floridians are many things, but they are opportunists first. In 1934, brothers John and F. E. Hemphill purchased Blue Springs, running simple boat tours down the river during these lean Depression years. In 1937, they partnered with Ocala entrepreneur Frank Greene and rechristened the whole operation with the zazzier *nom de guerre* "Rainbow Springs." They built a lodge and a gift shop to further monetize their scenic swimming hole. These were both fine specimens as roadside attractions go, made of stately stone, but they hardly distinguished the new attraction from other establishments popping up near Florida springs.

Rather, Rainbow Springs—which officially opened to the public on May 14, 1937—was most notable for its submarine boats—a variation on the classic glass-bottom boat which placed passengers below the waterline, eye-to-eye with the aquatic life present at the springs.

As a promotional brochure from the park's late-1960s heyday put it:

Rainbow Springs is a million fish. Big eyed fish, large mouth fish, fish you can see through. Fish that would turn Jules Verne green with envy. You'll almost rub noses with them in the world's clearest water on Florida's only Underwater Cruise.

The deep pit of a spent phosphate mine drops away from the edge of the park's access road. The forest around Rainbow Springs is littered with such depressions.

The swimming area at Rainbow Springs is carefully delineated from the wilder portions of the river. During the park's heyday until its closure in 1974, its distinctive submarine boats would have been an integral part of this scene. Now, motorized watercraft are forbidden in the upper 1,700 feet of the river, and the old submarine boat dock has been repurposed as a swimming platform.

Right: This brochure, dating from around 1959, puts Rainbow Springs' unique submarine boat concept front and center. The brochure's interior would go on to detail the attraction's manmade waterfalls, Jungle Trail, and convenient location along US 41. Curiously for a park which today features a prominent and popular diving platform, swimming at Rainbow Springs was barely implied in promotional materials through much of its roadside heyday. [*Courtesy of State Archives of Florida*]

Below: There was no swimming area labelled on maps produced during the attraction's final years. Promotional materials focused instead on the whizz-bang thrills of submarine boats, the glass-bottom paddle wheeler, and Forest Flite monorail. By contrast, swimming and paddling are the main draws for the park's modern visitors.

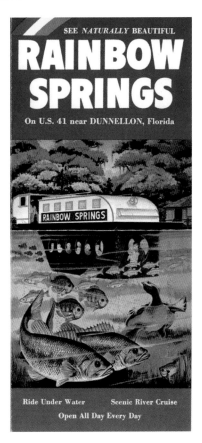

Visibility often exceeds 200 feet near the clear waters of the headsprings. That said, the purity of the river is imperiled by threats such as agricultural runoff. Water is noticeably murkier less than half a mile down river.

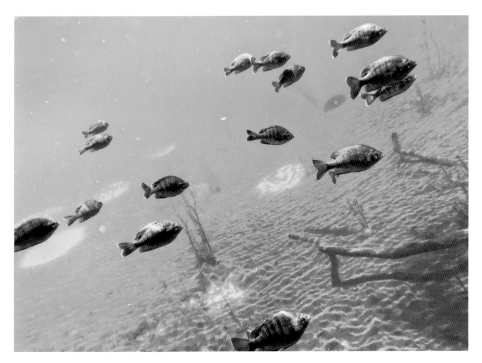

Vintage advertising boasted of Rainbow Springs' submarine boats and pilots (typically African American men) who delivered their script in a folksy patois: "FISHY STARES will greet you as you ride dry and comfortable five feet below the surface of the water. Though individual portholes you'll watch the unfolding of an underwater fairyland as the guide chants the story of this amazing wonder of Nature."

The water is still clear enough to see the keel of a neighboring kayak, but as at nearby Silver Springs, the "myriad of strange and colorful marine life" highlighted in promotional materials of yore has been seriously reduced in recent decades. This "mysterious world" is another casualty of the fluctuating oxygen levels and periodic algae blooms that go hand-in-hand with increased human activity in the 770 square-mile springshed.

To complete the scene, the countryside—so disordered after several decades of mining—was made-over to include botanic gardens and some reasonably impressive waterfalls flowing from the steep piles of tailings within the park. This was marketed in the same 1960s pamphlet as "natural Florida"—or some dreamscape version of it, anyway:

> Rainbow Springs is nature in abundance. It's majestic waterfalls. Crystal clear springs. Lush forests. Flower-scented air. Friendly animals and fun, fun, fun. Rainbow Springs is birds. Thousands of birds. Romantic birds, proud birds, fun birds, friendly birds. You'll rub shoulders with all of them as you escape on the Rainbow Springs monorail—a leaf-shaped sensation called Forest Flite.

That monorail, built in 1967, is long gone, but historic photos suggest it might better be described as a kind of gondola through the trees. Factor in a small zoo, some animal shows, an aviary through which the Forest Flite monorail passed (all those birds mentioned in the promo materials!), a rodeo, and submarine boats newly upgraded with AC—and by the late 1960s, it would seem like Rainbow Springs should have been playing with a stacked deck.

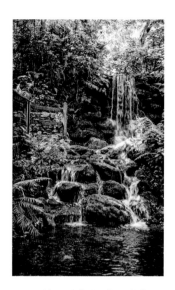

Above left: Rainbow Falls was advertised, truthfully enough, as "the highest waterfall in Florida—another perfect picture setting." However, promotional materials from the 1930s depict native women gathered at the falls, implying that they were a natural feature rather than an admittedly artful makeover of a phosphate tailing pile.

Above right: During the attraction's heyday, the gardens around the springs were home to plenty of exotic, nonnative vegetation. Since the early 1990s, Rainbow Springs' passionate volunteer corps has been involved in a long-term habitat restoration project, which includes prescribed burns, invasive plant control, and the planting of native species.

A pamphlet from the early 60s waxed poetic—"[The] ENCHANTING Jungle Trail winds around mossy oaks and tropical flowers bordering Rainbow Springs." While Silver Springs advertisements usually seemed to place beautiful women front and center, promotional art from Rainbow Springs more often depicted whole families having fun.

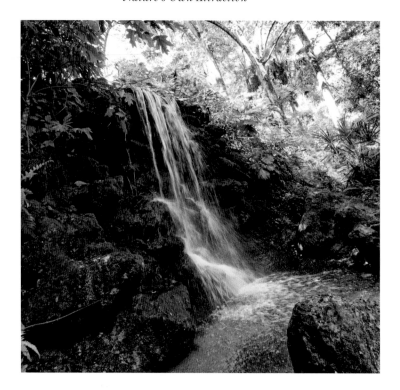

In January 1967, Walter Bienecke, heir to the S&H Green Stamps fortune, acquired a controlling interest in Rainbow Springs. It was under his guidance that the attraction's most ambitious additions were conceived. His Forest Flite monorail would have run over the heads of anyone on this path, if they weren't out on the river riding the simulated Huck Finn-style log raft.

The brochure summed up the situation pretty well:

Whoever said, "Life is a most wonderful fairy tale," probably said it at Rainbow Springs.
On U.S. 41 at Dunnellon. Only 18 minutes west of I-75.

For the record, it was Hans Christian Andersen who called life a fairy tale—perhaps a sentiment better expressed at Weeki Wachee.

But the more salient issue for Rainbow Springs were those directions. Eighteen whole minutes one way?

When I-75 opened in the mid-1960s following a route nearly parallel to US 41, the road for Rainbow Springs turned rocky. Traffic on US 41 fell a whopping 77% between 1963 and 1966 according to a 1967 report in the *St. Petersburg Times*—Rainbow Springs was officially "off-the-beaten path."

Still, the same kind of resourcefulness that had seen Rainbow Springs rise from the ruins of an abandoned mine continued to flicker like daubs of sunlight in the springs.

A campaign to rechristen nearby Dunnellon as the town of Rainbow Springs—a cheap way to buy some publicity, not to mention a slot on the green mile marker signs near the interstate—stalled out.

In 1970, Holiday Inn acquired a 50% stake in Rainbow Springs, announcing plans for an onsite 200-room lodge, but it was far too little, far too late.

A small zoo—labelled as "Animal Park" when it was added during the attraction's final late 60s iteration—featured fox, bobcat, raccoons, birds, goats, and deer. The enclosures were small, as was typical of the time, and located in convenient proximity for guests who disembarked at Forest Flite Station #2.

Given its relative lack of attention amidst the many other attractions at Rainbow Springs, it's ironic that the heavy stone and metal of the enclosures has outlasted almost everything else—save the springs themselves. The cautious visitor can climb inside and get a sense for what it must have felt like to be a fox or a bobcat on display for the amusement of the masses.

Trees form the zoo's only roof these days, and any animals you spot here are free to come and go as they please.

Disney World opened in 1971, and even your coffee-stained road atlas could tell you that the Magic Kingdom laid southeast of I-75, not west. Concurrently, the country was gripped by an energy crisis spurred by an international oil embargo. To conserve a newly restricted supply of petroleum, President Nixon lowered highway speed limits to 55 MPH—making the already long drive to Florida feel even more interminable. Increasing numbers of Americans were opting instead for a quick hop, skip, and jump to Orlando Jetport at McCoy Airforce Base, soon to be reincarnated as Orlando International Airport.

The long and the short of it was, no matter which way your compass needle was pointing, Rainbow Springs was out of the way.

By March 1974, Rainbow Springs was closed, another dwarf planet cast out of the state's entertainment firmament by the perfect alignment of a number of socioeconomic factors transforming American habits in the early seventies—not the least of which was the disruptive gravity of a supermassive black hole somewhere in the vicinity of Orange County.

The butterfly garden occupies roughly the same footprint as what was the Quarter Horse Farm and Rodeo Show during the Bienecke/Holiday Inn era. The foundations of the barn are still clearly visible, and the grandstand wouldn't have been too far from this gable.

Left: The sky-blue lupine is a native wildflower, widespread throughout most of the peninsula—the kind of plant now actively encouraged in the formerly exotic gardens of Rainbow Springs.

Below: Yellow-bellied sliders are one of the most common denizens of the Rainbow River. Though often spotted in the sun, they can be shy—shoving off their perch at the first human encroachment of their personal space. Easily identifiable by their banana-yellow plastron, these turtles can live up to thirty years in the wild.

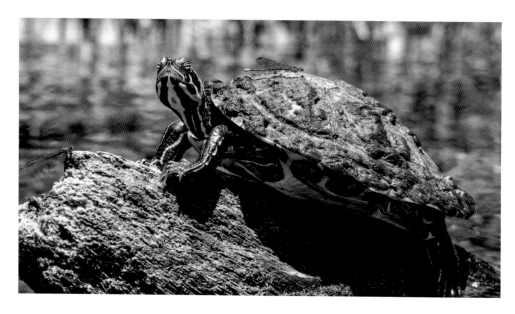

In 1966, one Otis Shriver claimed to have procured the remains of Osceola, announcing plans to erect a grand mausoleum for the Seminole leader at Rainbow Springs. Shriver dodged criminal charges when it turned out that Osceola's body was still very much in its grave at Fort Moultrie, South Carolina. He seemed as surprised as anyone when he learned he was in possession of a box of animal bones.

IN THE STATE PARK SYSTEM

The attraction at Rainbow Springs lay abandoned and overgrown with weeds for a decade. In 1984, a firm known as Chase Ventures acquired the property for a song. Various hang-ups—including renewed (or was it sustained?) public interest in the history and natural beauty of the place—brought any grand plans for the residential development of Rainbow Springs to a standstill.

Civically engaged Floridians are the real heroes of this current publicly-funded act of the Rainbow Springs story. By 1990, citizens had successfully lobbied the state to purchase the grounds of the old attraction. Though now safely in public hands, the ruined park needed some serious TLC. In the midst of a national recession, the state could not seem to muster those kinds of resources—so once again, citizens led the way, investing their own sweat equity to rehabilitate the overgrown land around the springs. For its first few years of existence, Rainbow Springs State Park was a Herculean volunteer-run project, open to visitors only on weekends.

The volunteers helped to define the three sections of today's park: the "headsprings" day-use area, which offers swimming, snorkeling, kayaking, and hiking; the tubing facilities, from which visitors may drift gently down river, observing wading birds, otters, and other wildlife present in the park; and the campground.

By 1995, the state was ready to step up, providing funds for a full-time staff. But even to this day, the park's operations are augmented by a particularly active Friends of Rainbow Springs volunteer group.

And the park is open seven days a week—just like nature intended.

This terraced array of viewing platforms and pathways was once at the crossroads of Rainbow Falls, the Forest Flite monorail, and the Rainbow Springs aviary.

There is a concept in ecology known as shifting baseline syndrome, used to describe the way in which successive generations fail to perceive the true extent to which our ecosystems are diminished. The first time anyone sees Rainbow Springs, they cannot help but stand in awe—but only because they have no idea how much more impressive it was generations ago, before the human impacts of the last century.

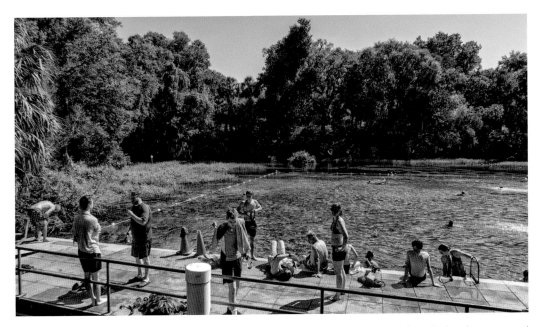

Under the auspices of the Florida Department of Environmental Protection, Rainbow Springs has recovered some of its historic luster. But old vacation photos prove that when previous generations of submarine boat pilots claimed that the variety of aquatic life was "really more than any one man could give you by name," it wasn't just flimflam. The same just can't be said about the fish population at the springs today.

It's easy to profess love for Florida's springs when you're out on the water—but it seems fair to ask whether that love is manifest in our actions as the state allows phosphate mining to continue unabated. When it allows the commercial bottling of water drawn from the Florida aquifer while sheepishly asking citizens to conserve? When it permits sprawling new housing developments where the land was wild before?

What did that first generation of Florida's road trippers see when they looked out over Rainbow Springs? And in what direction will the baseline shift by the time your grandkids inherit this treasure?

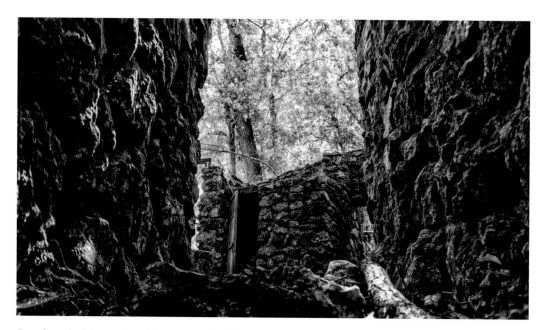

Too often, the false mantra of those unsustainably extracting our resources is "individual responsibly"—even when the problem at hand is so great that it requires the kind of bold collective action that rehabilitated this actual industrial wasteland into one of Florida's most exquisite parks.

3

Homosassa Springs Wildlife State Park

Homosassa Springs is Florida's most Natural Attraction where visitors walk under water to view the famous 'Fish Bowl Spring' and can watch more than 34 varieties of fish swimming together in this huge freshwater spring. Cruise the tropical jungle waterway ... stroll along the unspoiled nature trails ... feed the squirrels and deer ... see waterfowl of the world, playful otter s... sea lions ... and chimpanzees ... cringe as 'gators leap for fish ... linger in the beautiful Garden of the Springs. Fun, excitement and entertainment.

<div align="right">Homosassa Springs promotional material, circa 1970</div>

Like so many roadside attractions, Homosassa Springs—Nature's Own Attraction, as it was once marketed—featured a number of animal performances that look pretty suspect to modern eyes. Feed wild squirrels with your bare hands, take Buck the black bear for a walk on a leash, put Tiny the Chimpanzee in the driver's seat of his own little go kart—sure, why not? As recently as the 1970s, these true stories of wild animals as pet performers seemed like harmless fun to many of the attraction's guests.

These days, you won't see any animals performing at Homosassa Springs Wildlife State Park. Though, as its official designation makes pretty explicit, there's still a veritable ark's worth of creatures in residence—not for the mere amusement of visitors, but because these animals are in need of rescue, rehabilitation, and sanctuary.

They are wards of state, incapacitated because of havoc wrought by human activity elsewhere in Florida.

This most recent chapter for Homosassa Springs as a wildlife sanctuary seems to be a pretty fitting penance for an attraction that once dealt out its own fair share of animal trauma, all in the name of entertaining the roadside masses.

The Homosassa River rises at the springs, turning from brackish to saline by the time it empties directly into the Gulf of Mexico 7.7 miles downstream. Effectively an extension of the Gulf, the river serves as a vital highway for manatees and other marine life who require the springs' stable seventy-two-degree temperatures during colder winter months.

ROADSIDE HEYDAY

The first inhabitants of Florida, the Timucua and their even more ancient forebears, were no dummies. They knew a good thing when they saw it, and they seem to have rather quickly identified the virtues of settling near the freshwater springs strewn like so many jewels across north and central Florida. Signs of their occupation abound at Homosassa Springs.

After the decimation and removal of Florida's native population, the earliest documented use of Homosassa Springs came in the late 1800s. Around this time, it became an agreeable rest stop on the short rail connection between Ocala and the Gulf Coast. The so-called Mullet Train, which ran between 1887 and 1941, took on fuel in the form of freshwater and firewood for the steam engine, all while passengers recreated in the cool spring waters. The tracks are long gone, but the route of the Mullet Train is traced by Fish Bowl Drive, which leads visitors through the park in the twenty-first century.

In 1924, Chicago businessman Bruce Hoover made such a railroad stopover, calling Homosassa "the most beautiful river and springs in the world." Hoover was so enamored that he financed the construction of the first scenic foot bridge and observation deck over the springs, remarking, "I hope mankind will never see fit to destroy this spring, nor enclose it behind iron gates from the eyes of the world. For only God could create such a majestic sight. For truly it is a wonder of the world and a natural bowl of fish."

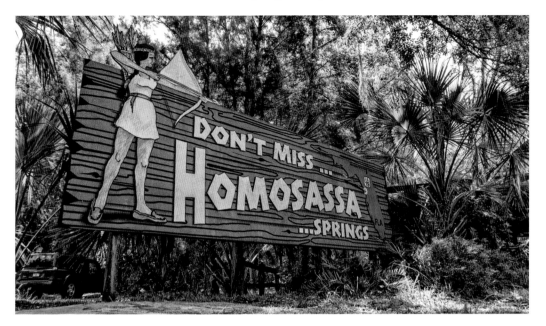

An extension of its brand as "nature's" spring, this stylized representation of a Native American princess was adopted during the attraction's 1960s heyday—as her miniskirt might suggest. It is the strongest iconography associated with Homosassa Springs. This reproduction of the original sign still stands alongside Fish Bowl Drive, which itself traces the even older route of the Mullet Train.

The springs lie approximately one mile from the main highway. If the pontoon boat ferry service along Pepper Creek isn't your speed—another vestige of the 1960s Norris era—a paved nature trail will guide you from the park's main visitor center on US 19. The pontoon ride no longer includes a chance to feed spider monkeys, who now live on an island down the Homosassa River, well outside the park's bounds.

Even as he uttered these inspirational words—coining phrases that would be associated with the springs down to the modern day—Hoover was involved in various schemes to promote the real estate value of the area. At some point in the thirties, Hoover was engaged in talks with railway speculators to bring a major north-south line through Homosassa, a suspect arrangement that would become the subject of Senate inquiry in 1942. His plans to plat a town amidst the cut-over timber land around the springs were ultimately thwarted by the Great Depression, and Hoover passed out of the Homosassa story.

In the years immediately following World War II, the brand new US 19 (which, by 1944, ran all the way from Eerie, Pennsylvania, to New Port Richey) carried a relative flurry of automobile traffic past the spring's doorstep—presenting a prime opportunity to fully monetize Homosassa's beauty.

In 1945, David M. Newell, a radio personality, adventurer, and author chronicling life on Florida's west coast, opened a 150-acre attraction at Homosassa Springs. Its main selling points were a three-story observation tower and an underwater viewing deck, the novelty of which was slightly diminished by its claustrophobic viewports. The underwater viewing deck did, however, feature jumbo ashtrays appropriate to the era!

Elmo Reed would purchase the park in 1950 and sell it again to Bruce Norris in 1962. Norris would install the attraction's most distinctive, larger-than-life elements.

Beginning in 1964, Homosassa's signature gimmick was a brand new 168-ton floating underwater observatory, a literal "Nature's Giant Fish Bowl" for the Space Age. An article in the January 1965 issue of *Popular Mechanics* describes the rig, launched on skids lubricated with "safe and slippery" bananas. Bananas were chosen (the article informs us) because they are "harmless" to fish and "edible" to man.

> Like the underside of an iceberg, the windowed observatory hangs beneath a roomy sundeck. Twelve thousand [1965] dollars' worth of two-inch glass gives observers a panoramic view of the 55-foot deep natural spring ...

This submerged deck still allows for a spectacular line of sight on dozens of fresh and saltwater fish who, drawn by the verdant, temperate waters of the spring, swim nine miles up the Homosassa River from the Gulf of Mexico. Saltwater varieties of fish present at the spring include snook, jack crevalle, sheepshead, snappers, mullet, ladyfish, and needlefish, among others. Acknowledging the cynical exploitation of animals occurring at so many roadside stops, a promotional pamphlet from the 1950s emphasized, "All these fish are free to come and go at will and are not imprisoned in any way ... an unbelievable sight!"

Maybe the most remarkable sight at Homosassa then and now are the mass gatherings of our distant mammalian cousins, the gentle West Indian manatee. These creatures are prone to hypothermia, so when the weather turns cold, they follow a treacherous route to reach the spring's balmy 72-degree water. These languid giants were certainly a novelty to the snowbirds who, not unlike the manatee itself, sought Florida's warmth every winter.

This earliest iteration of the Homosassa Springs roadside attraction, complete with restaurant and gift shop, emphasized observation of the natural surroundings, both above and below the water's surface. "The entire area around the springs is a wildlife

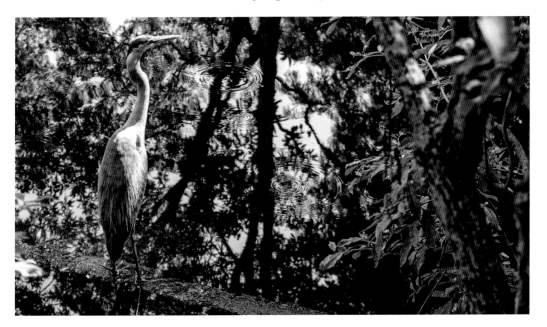

A great blue heron hunts in the placid waters of Pepper Creek. During the 1920s, this entire forest was slated to become the never-realized city of Homosassa. Florida's real-estate bubble burst just before the coming of the Great Depression, and this tranquil space was spared from the broader designs of one Mr. Bruce Hoover.

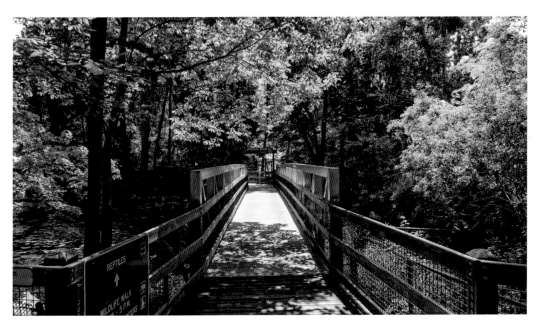

Within the park, a knot of boardwalks carries the visitor past a series of animal enclosures. From their earliest days, these have included natives like gators and otters, as well as "California sea lions (on a Florida vacation)," a lagoon stocked with "waterfowl of the world," and a chance to "walk among deer"—seemingly obligatory at roadside attractions in the 1960s.

Recreational boaters are barred from the park, though many proceed up to its edge—fishing, swimming, and relaxing right on the border. Heavy traffic from motorized boats is a persistent hazard to the manatees who rely on the river to feed and on the springs for warmth. Many of these languid creatures bear deep scars on their backs from close calls with some pleasure craft's propellers.

The Garden of the Springs was the primary swimming area from the 1880s heyday of the Mullet Train through the 1930s. Swimsuit rental was available from a stand nearby. Out of deference to the wildlife that rely on these waters, swimming is now prohibited within the park.

During his tenure in the 1940s, David M. Newell began to cultivate the garden area where this fiberglass bear resides. The nearby Children's Education Center building is a holdover from this period. Newell also constructed the first underwater observatory. Described as "an iron tank with small windows on each side," it was dubbed "Snook Cavern" in signage of the era.

Newell also originated the "walk under water" slogan, even as other signage at the attraction conceded that the "Fish Bowl can best be seen from the upper deck" of his three-story observation tower. Newell was a recognized conservationist who advocated for the creation of the Florida Department of Environmental Protection, which would ultimately assume stewardship of Homosassa Springs in December 1988.

At almost 2.5 inches in length, the great blue skimmer is a giant among insects. Unlike many of its dragonfly peers—who prefer open, sunny ponds—the great blue is well-suited to the shady, closer quarters found at Homosassa Springs.

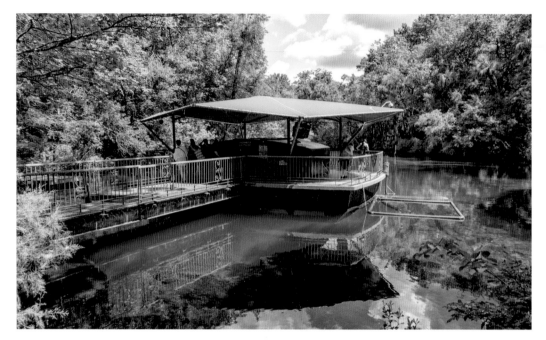

The current underwater observatory—known as the Fishbowl—replaced Newell's original version in 1964. Well into the twenty-first century, it continues to provide visitors the opportunity to "walk under water."

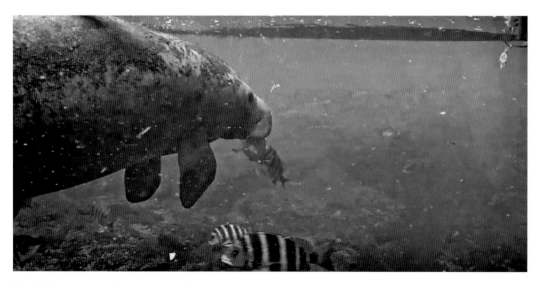

Though they received little to no attention in the park's earliest years, West Indian manatees are probably the most famous inhabitants of the spring in the modern day. The Fishbowl offers an incredible vantage on these magnificent mammals. A few, convalescing from particularly gruesome encounters with motorized boats, remain at the springs year round and can be viewed on the park's manatee webcam livestream.

refuge and a delight to nature lovers," a brochure from this period explained. In fact, the owner/operators were almost serenely overconfident in this business model. The same brochure continued, "There is nothing more beautiful."

I would tend to agree, but as competition between Florida's roadside attractions heated up in the latter half of the 1960s, "nature" at Homosassa Springs came to include something a little bit less native, a little less "not imprisoned in any way."

In 1969, Miami-based producer Ivan Tors, known for films like *Flipper* (1963), *Zebra in the Kitchen* (1965), *Clarence, the Cross-Eyed Lion* (1965), *Gentle Giant* (1967), and *Africa Texas Style* (1967), struck a deal that saw his troupe of exotic animal stars spending their ostensible down time performing at Homosassa Springs. In a March 17 article, the *Ocala-Star Banner* described the arrangement as "the nation's first animal actors' training school."

"The more often an animal is worked, the better actor he becomes," the center's director, whose title was "naturalist," told the *Banner*. "Therefore, we plan to work ours daily and expect to have the greatest stars in the county."

No doubt many a young visitor to Homosassa Springs during this period has fond memories of Judy the Chimpanzee or Clarence the Cross-Eyed Lion performing the same kinds of uncanny circus tricks that had made their peers—Flipper and Gentle Ben—into stars of the screen. None of the animals at Homosassa Springs ever worked in TV or film again, and the arrangement seems to have been a convenient way for Tors to subsidize the cost of their care. "The animals work for 'goodies' (cookies or candy)," the article explained.

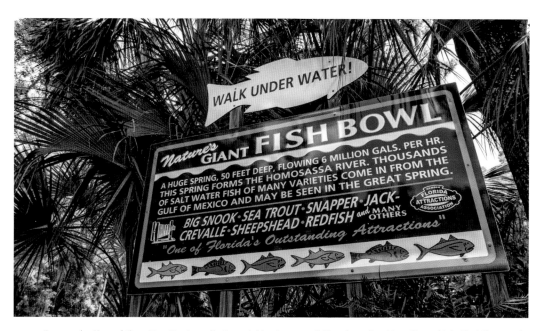

A reproduction of the attraction's earliest roadside signage, dating from the Newell era. Note that the words "Homosassa Springs" appear nowhere—it wasn't until Bruce Norris purchased the property in 1962 that the attraction took this name. Norris also bought up or established a number of ancillary businesses in the area, including the Sheraton hotel, Riverside Villas motel, and the Crow's Nest restaurant with its kitschy spiral staircase lookout point.

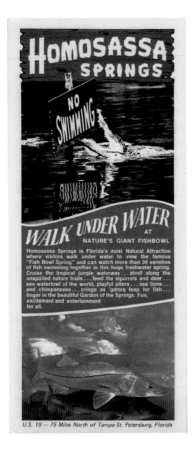

This late-70s brochure features one of the most striking images associated with Homosassa Springs. The "No Swimming" gator photograph was snapped on April 18, 1964, by longtime *St. Petersburg Times* staffer Bob Moreland, who said the photo, a fixture of kitschy postcards and promotional materials for decades to come, was completely spontaneous and unstaged. [*From the author's personal collection*]

IN THE STATE PARK SYSTEM

Homosassa's biggest star reportedly preferred marshmallows.

Lucifer the hippopotamus moved to Homosassa Springs after a brief career in campy, barely-remembered Tors-produced television series like *Daktari* (1966) and *Cowboy in Africa* (1967). This charismatic hippo would never become a big name in TV or movies, but his longevity and gregarious disposition would make him the unofficial king and mascot of Homosassa Springs—and since 1989, when rules about exotic animals in state parks threatened to cut short his reign, an honorary citizen of the State of Florida by special decree of the governor.

Homosassa Springs, Nature's Own Attraction, sustained itself with diminishing returns until 1984. As in the 1930s, the area was again in the crosshairs of developers—but this time, a grassroots organization known as Citizens to Save Our Springs put pressure on local government to intervene and save the faltering attraction. They prevailed, and Citrus County purchased the property. Over the next few years, management of Homosassa was gradually transferred to the state park system.

All the while, Lu reigned supreme. In the wild, hippopotamuses tend to live around forty years. Lu has defied that average, turning sixty in 2020—as happy and healthy as ever, save for a wicked case of arthritis in his tree-trunk knees, which support something like the weight of your car with his every step. For relief, Lu wallows in the cool spring waters, as he always has.

Volunteers and visitors alike greet him each morning with a hearty bellow of "Luuuuuuu!"

Lu responds with a reverberating guffaw of his own—a braying belly laugh reminiscent of Susie, a donkey friend from his show business days who once also made her home at Homosassa Springs. Lu may be one of the world's oldest living hippos, but all the attention hasn't gone to his head—he sounds as down-to-earth as your boisterous uncle.

And just like some bawdy uncle, Lu has a few tricks up his sleeve that aren't quite ready for primetime. Wait until you see what he can do with his tail ...

Imagine the rotors in a blender set to high, and you're on the right track. Stand back unless you've brought a change of clothes, because when Lu is around—*it* hits the fan.

Reincarnated on New Year's Day 1989 as Ellie Schiller Homosassa Springs Wildlife State Park, the 210-acre Homosassa facility builds on the infrastructure of the old roadside attraction, carrying out a two-pronged mission of public education and wildlife rehabilitation. The springs now house a rotating cast of convalescent manatees, brought from all over the region after debilitating—still far too frequent—collisions with recreational boaters.

A veterinary staff, supplemented by a genuine army reserve of volunteers (mobilized through the non-profit Friends of Homosassa Springs, founded in 1991), do their best to care for these and other creatures—including a Florida panther, black bears, and red wolves. This menagerie is mostly here after a myriad of unfortunate encounters with humans and the Florida they are building.

None of the creatures at today's Homosassa Springs are asked to perform for their daily nourishment. Benefactors like Ellie Schiller, the park's namesake, as well as anyone paying admission—or paying their taxes, for that matter—contribute to the care of these vulnerable animals. Those that can be released, are. The animals that can no longer make their way in the wild find berth at Homosassa or are relocated to a more appropriate refuge elsewhere.

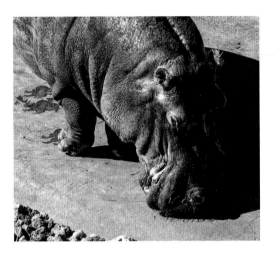
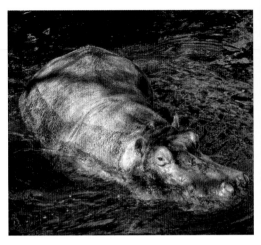

Above left: On August 3, 1986, the *Citrus County Chronicle* reported, "Lucifer the hippopotamus would be removed [in accordance with Florida law] if the state government ever took over the [county] park, as has been proposed. For Lucifer-lovers, that raises another question—how long will he make his home here?" Lu would be saved by the passion of his fans, granted special permission by the governor to remain.

Above right: Lu was born at the San Diego Zoo on January 26, 1960, weighing 90 lbs. His adult weight is approximately 6,000 lbs.—one of the many reasons he spends so much time wallowing in the cool spring waters. Daily, Lu consumes 15 lbs. of alfalfa, a 5-gallon bucket of fruits and vegetables, and a heroic quantity of ibuprofen for the joint pain in his aging knees.

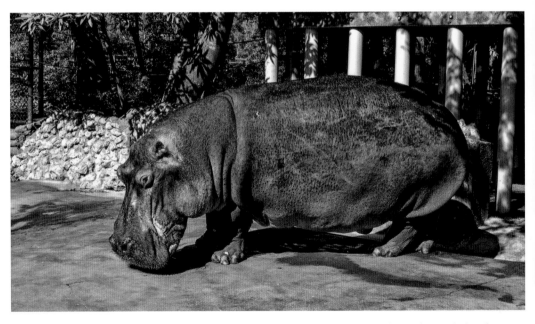

Despite his tranquil demeanor, Lu is a dangerous animal; hippos don't have great eyesight, can be startled easily, and are responsible for hundreds of deaths a year in their native Africa. In 2017, during a high-water period following the intense rainfall of Hurricane Irma, Lu injured a manatee who accidentally gained access to his enclosure.

Biddy came to Homosassa Springs when she was orphaned as a cub. She may be safer behind bars than anywhere else. Black bears once roamed the state's entire length, but only a few thousand animals remain—the victims of habitat loss and overhunting in previous generations. In 2015, the first hunting season in twenty years saw more than 300 bears killed in a two-day period.

Florida is home to two pelican breeds—the larger white pelican is a literal snowbird, while the brown pelican is a year-round resident. Though currently listed as a species of least concern, brown pelicans eat four pounds of fish each day and are highly dependent on the precarious health of Florida's fisheries. Individuals like those seen here are most often injured by discarded fishing line and hooks.

The North American river otter is native throughout Florida, except the Keys. They feed on fish, crayfish, frogs, and eggs. The greatest threat to the species is habitat loss as river systems and wetlands are disrupted by human development. In Florida, it is legal to hunt and trap otters, with certain restrictions.

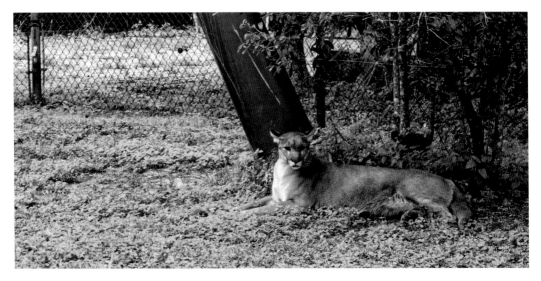

Yuma was found as an emaciated kitten on January 23, 2014. Likely an orphan, he was subsequently nursed to health by humans and cannot be returned into the wild—where, as of 2020, only about 150 panthers survive. Habitat loss is the greatest threat to this top predator. As their territories are fractured, they struggle to find food, coming increasingly into contact with cars and environmental pollutants like mercury.

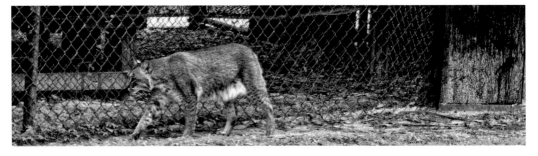

Homosassa Springs is the permanent home of two bobcats—Tank and Antonio. Both were previously raised as pets—which is legal in Florida with a permit. Their fate is a cautionary tale, however. Despite their modest size, bobcats are not housecats. Because both Tank and Antonio have imprinted on humans, and it is unsafe to release them into the wild.

Bald eagles are occasionally injured in collisions with manmade objects such as power lines. This bird's wing suffered just such a debilitating fracture. In addition to being skilled hunters, bald eagles are scavengers. Lead-based ammunition, unwittingly consumed along with carrion, is hazardous to Florida's estimated population of 3,000 eagles.

Green herons usually keep to themselves, hunting prey near the water's edge. This little guy is not an official ward of Homosassa Springs but seems to have realized that food is easy to come by near the boardwalk. Sometimes even our best intentions have unintended consequences for the wildlife around us.

Above left: Whooping cranes face devastating habitat loss along their migration route, and as a result have become the world's most endangered crane. Peepers, seen here, suffered an injury that prevents her from flying, but shares her enclosure with Levi, a healthy male who has bonded with her and never leaves her side.

Above right: This handsome caracara is native to a small range in central Florida. Homosassa Springs works with Florida Fish and Wildlife Conservation Commission, Tampa's Lowry Park Zoo, and other partners to provide a home for Florida creatures that are injured, imprinted upon humans, or otherwise incapable of caring for themselves in the wild. Sadly, demand for such services are consistently in danger of outpacing available space.

During the attraction's 1960s heyday, visitors were invited to handfeed and intermingle with a captive herd of deer—an experience then also offered at Silver Springs. The current residents—whitetail and key deer—are rescued animals and are not fed by visitors. The 2017 boardwalk leading to their enclosure is proof of the continued strength of Homosassa's "Friends of" group, representing $100,000 worth of volunteer-organized funds.

It's truly remarkable how many of Florida's predators—so fierce in the fairy tale, roadside version of nature once peddled at attractions such as Homosassa—are today threatened by cars barreling along our many highways.

Sadly, the animals housed at Homosassa Springs represent just a small fraction of the majestic wildlife that experiences a debilitating encounter with humans in any given year. Florida is a state that owes so much of its prosperity, so much about its way of life, to the automobile and the freeways which carry them.

Like a speeding car, all things must pass. Just as these roadside attractions eventually fell out of favor, retired into the park system as novel relics of a bygone era, there are a few other things Floridians might learn to consider passé.

Specifically, we might consider reordering our way of life—reassessing the Florida Dream of an infinitely sprawling tessellation of subdivisions linked by a spider's web of expressways. This irresponsible pattern of development threatens to turn broad swathes of Florida's native habitats into veritable islands. In the twenty-first century, we are too sophisticated in our knowledge of the natural world to ignore our species' impact on the wilder inhabitants of our state.

While Homosassa Springs Wildlife State Park is a respectable start in healing Floridians' relationship with our wildest neighbors, we might consider other acts of goodwill to further the cause. Off the top of my head, it would be great to implement state-wide policies promoting:

Animal underpasses, safely linking wild areas on opposite sides of existing expressways.

More vertical construction in established urban areas, and less sprawl.

No new expressways, especially those that would bisect natural habitats.

Combined, those three measures would certainly decrease the number of animals in need of care at Homosassa Springs, as well as other zoos, sanctuaries, and animal hospitals doing similar work throughout the state. More broadly, these modest proposals represent the very least we can do for nonhuman Floridians of all shapes and sizes. There are groups already advocating for these goals, including the Florida Wildlife Corridor, the North Florida Land Trust, Florida Conservation Voters, and others. They could use your support!

On that note, don't wait until the next well-funded proposal to carve up wild Florida comes barreling down the pike—make it common knowledge among our elected officials that nature has a vocal constituency across the state. Let state legislators and the governor know how you feel today!

Because as impressive and charismatic as these animals are, they cannot speak for themselves.

Florida's flamingos were hunted to the brink of extinction during the early twentieth century when their feathers were used as fashion accessories. So few remained that for decades, scientists were convinced that the flamingo was not actually a native species. But a growing population in the wild, coupled with birds tagged in the Yucatán who have taken up residence in Florida of their own accord, has shifted this view.

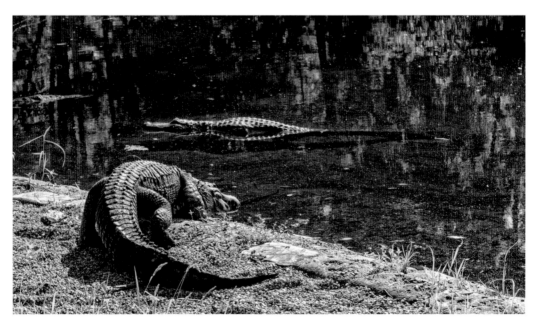

Once hunted to the edge of extinction, Florida's alligators have made a full recovery under the cover of strict protective regulation. Their biggest threats in the twenty-first century, like so many other Florida natives, come from habitat loss as a result of human development. Alligators are also vulnerable as rising sea levels contribute to the gradual saltwater inundation of Florida's freshwater ecosystems.

The headsprings are open to a multitude of manatees each winter. In between, they are closed off as a recuperative space for manatees critically injured in collisions with boats—many on the Homosassa River itself.

"As if Citrus County doesn't have enough pains as the nation's 15th fastest growing county, along comes the sudden interest in a funny looking creature of the watery deep whose survival seems in no small way dependent on how Citrus Countians respond to their need," opined the *Citrus County Chronicle* on January 14, 1971, seemingly put out that this inconvenient mammal might require special protection.

Homosassa Springs is home to one of the premier manatee care centers on Florida's Gulf Coast. Instrumental in its creation was Dr. Jesse White, an early trainer of Ivan Tors' Flipper, who turned his attention to studying, conserving, and rehabilitating manatees. He was also a prominent advocate for the first legislation to protect the species.

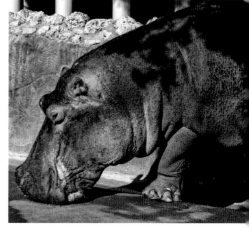

Above left: As manatee populations continued to languish in the face of public indifference, White dedicated the final years of his life to educating children. "Through them, we can get to their parents, their brothers, their uncles," he told the *St. Petersburg Times* in 1988. "You can teach them a respect for the rivers and the environment ... I think that's the way to go. Old codgers like me, it's hard to change."

4

WEEKI WACHEE
SPRINGS STATE PARK

At each performance a lovely mermaid attempts a 117 foot deep dive into the depths
of Florida's famous underwater grand canyon.
 Bob Hope says, "The live mermaids are the greatest at Weeki Wachee … and it's fun!"
 Weeki Wachee promotional brochure, 1960s

Weeki Wachee is, in so many ways, the apotheosis of roadside Florida, the all-time crown
jewel gold standard. It is fantasy and nature and retro kitsch all rolled into one, with a
history dating back to 1947—a period when today's grandparents were pioneering the
"great American road trip" with their own parents. Weeki Wachee is simultaneously of
its era and timeless, posing the wistful question in big, bold calligraphic font: What if
mermaids were real, and they inhabited a stunning natural spring conveniently located
at the intersection of US 19 and State Road 50?

For millennia, the Weeki Wachee River has arisen at the spring of the same name. The water's famous clarity is deceptive, suggesting tranquility. Currents are reasonably strong and steady, especially near the headsprings where they flow at around five miles per hour. Every day, the river carries some 117 million gallons of crystalline water over twelve winding miles before emptying into the Gulf of Mexico.

ROADSIDE HEYDAY

Newt Perry, the visionary behind Weeki Wachee, was an all-American hometown boy who made good.

As a teenager in Ocala, Florida, during the 1920s, Perry fell in love with Silver Springs. The story goes that Perry, scion of a modest working-class family, would hike a full six miles to the attraction, one way, just to get some time in the cool, clear waters of the spring. He drew attention almost immediately for his power, grace, and whimsy under the water. Attraction owners Carl G. Ray, Sr. and W. M. "Shorty" Davidson invited Perry and his also-talented sisters to put on exhibitions at Silver Springs for the benefit of visiting journalists.

Perry would showboat, swimming freestyle against the current, performing somersaults, eating bananas, drinking soda, and riding a bike—all underwater, pioneering a brand of showmanship uniquely suited to Florida's crystal-clear spring waters.

Perry parlayed this early exposure into a part-time career. He modelled for an edition of the Red Cross's aquatics safety manual, hammed it up in the pages of *Life* magazine, was a favorite subject of famed sportswriter Grantland Rice, and performed stunts in such Hollywood productions as 1939's *Tarzan Finds a Son!*

As he entered middle age, Perry remained as ambitious as ever. However, he had probably come to recognize that his prime years as a swimmer were largely behind him. What's more, the ones who made any real money on the roadside were not usually the performers but the owners. With all of this in mind, Perry scouted out Weeki Wachee Springs in 1947.

A 2015 survey identified ten species of turtles within the bounds of Weeki Wachee State Park—the highest level of diversity of any spring in Florida. These turtles are a common sight along the river and have even been known to wander unwittingly into mermaid shows from time to time.

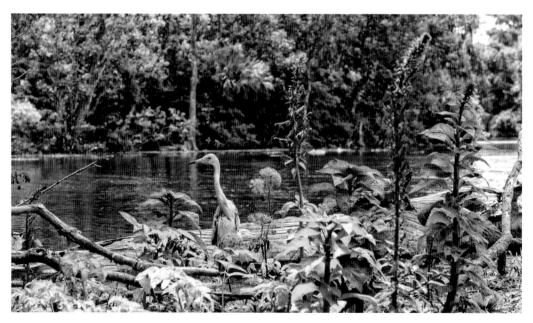

Wading birds are a common sight along the river's length. Likewise, numerous wildflowers, such as the distinctive red cardinal flower, grow prodigiously in sunlit expanses during high summer. This perennial can grow up to four feet tall and is a favorite of ruby-throated hummingbirds and swallowtail butterflies.

Weeki Wachee is arguably the most impressive of any spring in Florida. It yields forth some 117 million gallons of crisp, 74-degree water a day. The 100-foot-wide basin is actually the doorway to a much larger subterranean cave system—at least 407 feet deep, making it the deepest known freshwater cave system in the nation.

At the time, this stunning natural cathedral was consigned to service as the local dumping pit. After clearing out a grab bag of detritus—consisting of broken-down major appliances and decomposing jalopies too junky even for the junkyard—Perry set about constructing a modest eighteen-seat underwater theater mounted directly into the limestone at the edge of the spring.

A born entertainer, Perry knew all that natural grandeur was just theatrical set dressing. Novelty was a must in the roadside attraction game. He needed to set himself apart from the competition immediately.

Perry devised an ingenious system of breathing tubes capable of supplying fresh air to underwater performers and positioned them discreetly behind the rough limestone outcroppings along the walls and floor of the pool. He created a similar array to line the windows of the theater to create a veritable curtain of bubbles at dramatic moments during the performances occurring in the crystal waters beyond the glass.

Drawing upon his experience as a swim instructor (he had served as coach of his own high school swimming team beginning at the age of sixteen, had majored in education at University of Florida, and had drilled Navy Frogmen-in-training during World War II) Perry set about recruiting and teaching local girls to swim, breathe, and perform in his one-of-a-kind theater.

On October 13, 1947, the young women performed the first Weeki Wachee live show, presenting a routine drawn from Newt Perry's lifetime of underwater showmanship. Over the next several years, this show would gradually take on most of the mermaid iconography so strongly associated with Weeki Wachee.

Between shows, these lovely mermaids would sun themselves, wave, and smile from the dusty edge of US 19—tempting the next round of audience members to gawk, brake, and ultimately swing the family sedan into the gravel parking lot.

Weeki Wachee was no overnight success, though. Instead, it steadily built a reputation through the 1950s as one of the rare roadside attractions to live up to its own hype. This was no phony-baloney Mystery Spot. It was not one of two towns in the Midwest claiming to be the home of the world's largest ball of twine. (Fifty percent of the people who think they have seen the record holder are unwitting dupes!)

These were real live mermaids capering for your amusement—offering something for every member of the family, with both a price and a view that dad could get excited about.

In 1959, Perry finally sold the business to the American Broadcasting Company, one of the big three television networks. At the time, ABC sought to diversify its interests by getting in on the craze for amusement parks that had taken off like a rocket a few years earlier, thanks to a little park out in California called Disneyland.

Weeki Wachee seemed poised to become the crown jewel in the broadcast giant's fledgling amusement park empire. ABC invested in a brand new 400-seat "Underwater Aqua-Theater," the same one in operation today. It also advertised and cross-promoted heavily, setting TV specials among the mermaids and encouraging stars as far ranging as Elvis Presley, Don Knotts, and Arthur Godfrey to offer up a pull quote or two for the promotional literature that was distributed to every gas station and motel in the state.

Above left: The Underwater Theater seats some 400 spectators fourteen feet below the surface of Weeki Wachee Springs Mermaid Lagoon. Built in 1959 for a reported cost in the range of $1 million dollars, the theater's thick plate glass windows manage to impart a sense of widescreen wonder even after all these years.

Above right: The original 1947 theater was designed to accommodate a mere twenty guests who were seated directly in front of small glass portals, each affording a rather claustrophobic vantage on the mermaids performing in the spring beyond. These early shows were often narrated by Newt Perry himself, who stood directly behind the audience while providing color commentary.

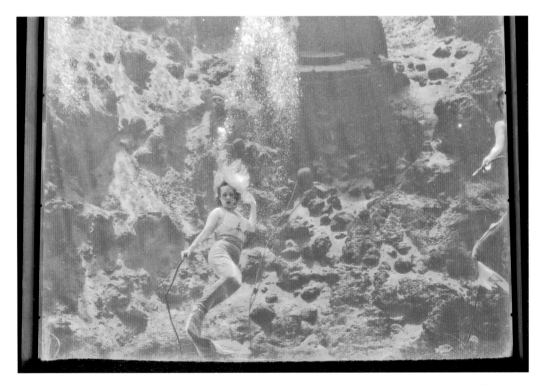

Clearly seen in this mermaid's hand is one of several breathing hoses that make Weeki Wachee performances possible. All the show's performers are accomplished free divers, many capable of holding their breath for up to four minutes between life-giving gulps of air.

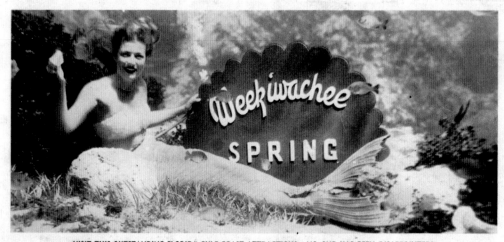

VISIT THIS OUTSTANDING FLORIDA GULF COAST ATTRACTION! NO ONE HAS BEEN DISAPPOINTED!

A 1949 brochure from Weekiwachee (originally spelled with no space, but later broken up to make the unfamiliar word more readable) showcases the attraction's newly-adopted mermaid theme, inspired by a Universal Studios film called *Mr. Peabody and the Mermaid*, shot at the spring a year earlier. Nancy Tribble was a Weeki Wachee regular and underwater double in the movie. [*Courtesy of State Archives of Florida*]

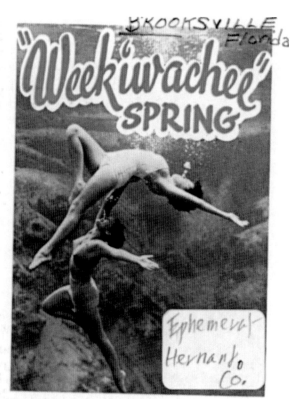

The mermaid theme is so natural it seems like it must have been part of Weeki Wachee's shtick from the start. In fact, the attraction's original 1947 tagline was "The Mountain Underwater." On the other hand, this iconic adagio routine—today represented on the park's highway sign and its entryway fountain—has been a showstopper at Weeki Wachee from its earliest days. [*Courtesy of State Archives of Florida*]

In All This World There Is Nothing Like...

WEEKIWACHEE SPRING
The MOUNTAIN UNDERWATER

*Florida's Newest, Most Amazing Attraction
On the Main Gulf Coast Highway* **US 19**

WORLD'S ONLY
Underwater Theatre

Spectacular swimming and ballet shows! Deep water diving by a world champion! ALL - UNDERWATER PER-FORMANCES! 5 shows week-days. Sundays at 10:30, 11:30 a.m. and continuous there-after.

BE SURE TO
Bring Your Camera

Nowhere in the world can you take such thrilling under-water pictures . . . such breath - taking underwater beauty, and grandeur. This is a photographer's paradise!

Perry's Gift Shop. The most talked-about gifts of individuality in the State of Florida.

On your trip to Weekiwachee Spring you will also enjoy seeing the Sponge Fleet at Tarpon Springs and Homossassa Springs, Nature's Giant Fish Bowl. For information write Weekiwachee Spring, P. O. Box 194 or 82, Brooksville, Fla.

In 1947, the attraction's first year, all roads led to Weeki Wachee. In the era before GPS or the Interstate Highway System, simplified route maps were a vital part of advertising for any roadside attraction. It almost seems like a visitor to Florida *had to* visit Weeki Wachee! [*Courtesy of State Archives of Florida*]

During these salad days, ABC had thirty-five mermaids on staff, including some who lived on site in so-called "mermaid cottages." ABC upped the attraction's production values, too, staging lush underwater re-enactments of *Alice in Wonderland*, *The Wizard of Oz*, and *Peter Pan*, all presented through an improved sound system.

In 1966, with I-75 fast nearing completion and threatening to siphon a critical mass of through traffic off of US 19, the town of Weeki Wachee was officially incorporated. This deft move quite literally put a name synonymous with underwater mermaid shows on maps and green road signs—all on the public dime. How much this stunt actually helped the attraction to weather the lean years of the next decade—even as so many of its roadside peers went underwater—is probably unknowable. But it certainly doesn't seem like such a steady presence on freeway mile marker signs around the western portion of the state could have done anything to hurt Weeki Wachee's fortunes.

That said, you can probably guess the general arc of this story by now. The cratering attendance wrought by the arrival of Disney; the fuel crisis, eating into the miles Americans were willing to drive; the interstate highway system, which made those miles more direct and efficient at the expense of so many small towns and mom-and-pop businesses the nation over; more convenient flights, including those offered by the likes of Florida's own National Airlines—none of it was good for business.

Unsustainable recreational use is taking a heavy toll on the Weeki Wachee River. A study published by the Southwest Florida Water Management District in June 2019 concluded that heavy boat traffic (especially by motorized craft), the practice of docking and exiting watercraft on the river's banks, and the artificial beach at Buccaneer Bay are negatively impacting the river's health.

The cumulative effect of this overuse is that the Weeki Wachee is silting up at a historic rate, becoming demonstrably broader and shallower with each passing year. Like Florida's other spring-fed rivers, Weeki Wachee is an important habitat for manatees, whose access to the warm waters of the river are among the many aspects of the ecosystem imperiled by these human impacts, unintentional as they may be.

But even as more families were hopping a cheap jet flight to the Magic Kingdom, missing out on the version of roadside Florida that had been such a crowd-pleaser just a few years earlier, Weeki Wachee managed with some success to position itself as "just a day trip away" from Orlando by rental car. It's not hard to see a straight line between the two attractions, whether on a map (an uncomplicated straight shot down Florida 50) or in terms of overlapping audience demographics (the kind of folks primed for a day of fantasy spectacle).

Ironically, Disney productions would do more than Weeki Wachee itself to keep mermaids in the popular imagination over the ensuing decades. The clearest latter-day example, of course, was the successful and enduring 1989 adaptation of *The Little Mermaid*. This film is often credited with jumpstarting a renaissance in Disney's beleaguered animation division. It would be no less accurate to acknowledge that the film also infused some measure of life (and cash) into Weeki Wachee, which was otherwise beginning to feel more than a little dated to audiences of the 1980s and 90s.

The Southwest Florida Water Management District recommends a ban on motorized craft for much of the river's run, a stricter limit on the number of boaters allowed to access the water on any given day, as well as disallowing the popular practice of docking craft at undesignated points along the river.

As of 2020, such regulations exist within the stretches of the river that pass through state property—though it is hard to argue that they are clearly posted. It is likely that the Weeki Wachee River will become yet another flashpoint in Florida's ongoing struggle to balance the personal preferences of its citizens with the interconnected ecological imperatives predating any human presence on the peninsula.

IN THE STATE PARK SYSTEM

By the early 2000s, Weeki Wachee Springs was a tourist attraction in name only—tourists just weren't coming. The park was in decline, with peeling paint, cracked plaster, and daily audiences counted in the tens rather than the thousands. It was an eerie and sort of sad sight, though the faltering business was a fair representation of old roadside Florida in the wake of Orlando's theme park ascendancy. Positioning itself as a budget-conscious add-on to Disney World had prolonged Weeki Wachee's lifespan, but the truth was that it was hemorrhaging money, about to go the way of so many of its defunct mid-century peers.

The last in Weeki Wachee's succession of private owners handed the insolvent attraction over to the humble city of Weeki Wachee, the town originally founded as part of a promotional scheme for the park it was now being asked to save. In 2008, city hall, lacking the wherewithal to manage the water park any longer, reached an agreement with the State—the attraction would thereafter be known as Weeki Wachee Springs State Park.

It's easy to get caught up in the showbiz of Weeki Wachee. In that regard alone, the park is a vital slice of Florida's modern history, a vivid holdover from the time when this scrubby, swampy, scrappy little peninsula of ours was figuring out how to present itself to the rest of the nation. The park's facilities were given a modest facelift on the public dime—though the state's main interest lies in the conservation of the springs and natural habitats on the attraction's margins.

There's so much more going on within the 500-acre bounds of the Weeki Wachee that make it a natural addition to Florida's State Park system.

Despite the addition of a water park known as Buccaneer Bay in 1982, complete with wave pool and water slides, Weeki Wachee has managed to maintain a good reputation as a prime spot for diving, kayaking, and canoeing. Located just twelve miles upstream from the Gulf of Mexico, the adjacent waters continue to play host to manatees, otters, turtles, snakes, and a variety of fish. In fact, a "Colorful Adventure Cruise on the Beautiful Winding Weeki Wachee River" has been part of the promotional materials almost from the beginning—usually illustrated with a tiny alligator icon.

There's a history on display at Weeki Wachee that predates the roadside era, too. In 1969, during an expansion of the roadside attraction, a bulldozer operator uncovered a skeleton that was initially mistaken for a murder victim. Closer inspection revealed pottery, beads, and other artifacts spewing forth from a sandy, 13.7-meter-wide mound. Archaeologists from the University of Florida determined that the mound was used by the Safety Harbor Culture for ceremonial burials between 900 and 1650 CE, and that it contained items of Spanish origin including silver coins that dated between 1525 and 1550. In other words, long before it became the city of live mermaids, the spring at the headwaters of the Weeki Wachee River was regarded as something even more sacred and special by Florida's original inhabitants.

This discovery led to the erection of an unfortunate memorial plaque featuring an outmoded depiction of Native Americans as simplistic and ready to worship anything they didn't understand. Its text is a historical relic of a different sort:

Weeki Wachee has presented some form of riverboat tour since the early days of the attraction. Known as the *Congo Belle* Adventure Cruise, visitors once rode a glass-bottom sidewheel riverboat through romanticized recreations of scenes from Florida's past, interspersed with featured performances by trained animals. Today, the *Aqua Belle* is given a more sober billing, offering "a tranquil ride down [a] pristine waterway."

No doubt, on a sunny morning in the 1530's a Spanish galleon dropped anchor off the gulf coast a few miles from here. A boat was lowered and an advance guard of armor-clad Spanish explorers headed for the shore. They worked their way up the bands of the winding river and came face to face with the Timucuans. The Indians, thinking they were in the presence of Gods, offered their humble reverence to the Spaniards!

As of the early 2020s, Weeki Wachee seems to have attained a rarefied position in the pop culture firmament. It maintains an ineffable aura of timeless retro cool, with the kind of cultural cache that even Disney can't manufacture on any reliable basis.

Real-life mermaids may be rare, but for now, at least, they're off the endangered species list.

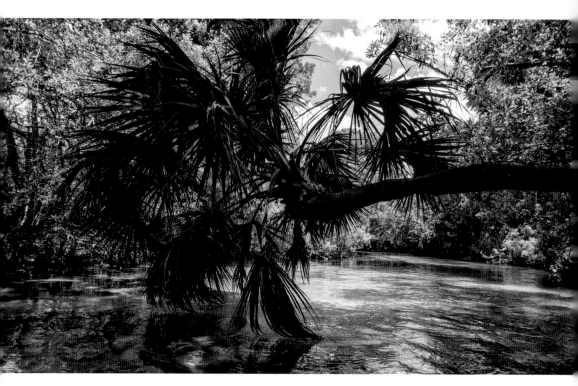

There's still tranquility to be had on this well-loved river—but you must get up pretty early to experience it. The most popular kayak trip is a leisurely 5.5-mile float downriver from Weeki Wachee Springs State Park to Roger's Park in Spring Hill. For the most determined, an upstream paddle is possible along the same route.

Cypress knees sprout along the river's edge. They are attached to the tree's root system, providing increased stability in the soft, saturated soil found along the Weeki Wachee.

Cypress trees are coniferous. Narrow and needle-like, their leaves seem to glow like a corona in the early morning sunlight.

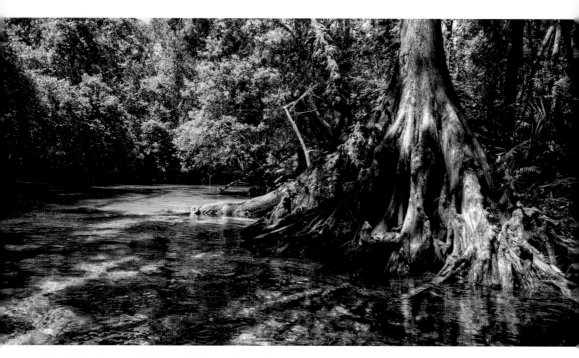

The distinctive tapering base and flakey red bark of the cypress tree are easily recognizable.

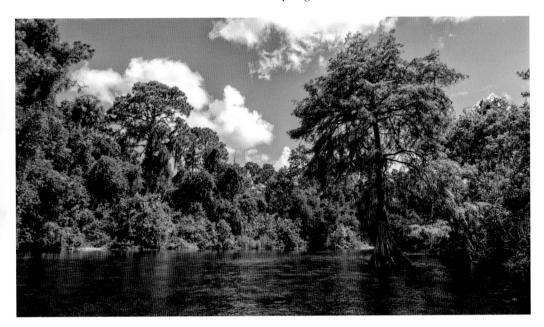

Florida is home to two varieties of cypress—the pond and the bald. The pond cypress is the smaller of the two, usually found in still waters. The bald cypress is more common along rivers. It can live as long as 600 years, growing to a height of 150 feet under ideal conditions, making it the tallest tree east of the Rocky Mountains.

Substantial sand deposits on the bends of the winding Weeki Wachee River are known as point bars. A sure sign of heavy erosion in the river, they make tempting *ad hoc* beaches—but their use for this purpose only serves to compound the problems of turbidity and silt downstream.

The world below—vegetation like eelgrass serves as an important source of food for manatees and turtles alike, while simultaneously improving water clarity and stabilizing shorelines. When paddling, rafting, or swimming in any of Florida's rivers, it is of vital importance not to disturb any submerged plant life.

These "mermaid tresses" are a type of algae known as spirogyra. This type of runaway algal growth is a sure sign of poor water quality. Blooms are caused by excess nutrients introduced into the waterway by runoff from human activities. The phenomena is evident in every one of Florida's once pristine spring-fed rivers.

Conclusion

Florida's roadside state parks are products of a different era, a time when showmen and entrepreneurs were able to build successful businesses around the wonders of nature. These wonders were presented, of course, with a touch of the razzle-dazzle showmanship that has made Florida virtually synonymous with theme parks. And in this sense, the springs represent not only our natural patrimony, but also our cultural heritage as Floridians—the places where Florida's modern tourist economy was invented in real time.

That anything-goes commercial golden age has long since passed. But Silver, Rainbow, Homosassa, and Weeki Wachee Springs have given forth so much more than just a steady flow of crystalline water over the decades. They are the beating heart that circulates life throughout our peninsula, almost literally. They are the most obvious manifestation of the giant aquifer beneath our feet—the abundant, but not inexhaustible water supply that defines life in Florida.

What is more, these springs continue to evoke a genuine affection from their surrounding communities. This affection takes the form of an abiding love for wild Florida, a nostalgia for the thrill of childhood visits to the roadside attractions that once thrived in our midst, and a desire to pay these experiences forward to the next generation. Without the tireless energy of the respective "Friends of" groups—who channeled their love for the outdoors into political action; who have subsequently cleared untold numbers of weeds from cracked concrete; and who continue to donate tens of thousands of collective volunteer hours each year in service of their chosen park—Florida's "Big Four" springs might today be namesake showpieces at the center of large housing developments.

I, for one, offer my thanks to these uncommonly passionate citizens and to their political representatives, who came took action to memorialize Silver, Rainbow, Weeki Wachee, and Homosassa Springs for what they are: priceless public treasures to be cherished, preserved, and enjoyed by all.

May the current generation of Floridians also prove to be worthy stewards of these crystal waters!

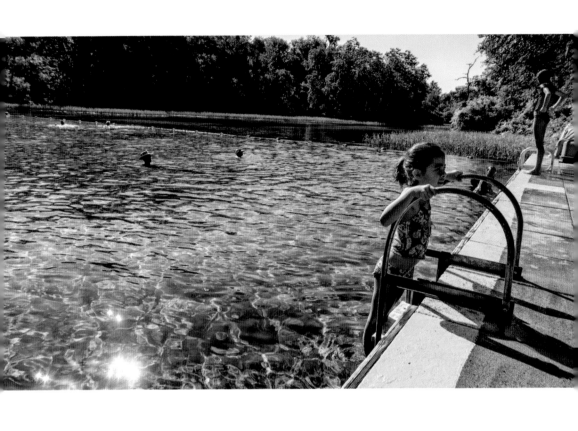

FURTHER READING

The following works provided valuable signage on the highway to writing this book. I swim in the current generated by these headsprings of historical knowledge:

Glass Bottom Boats & Mermaid Tails: Florida's Tourist Springs by Tim Hollis, Stackpole Books, 2006.
Remembering Paradise Park: Tourism and Segregation at Silver Springs by Lu Vickers and Cynthia Wilson-Graham, University Press of Florida, 2015.